MURALS OF THE
PALM BEACHES

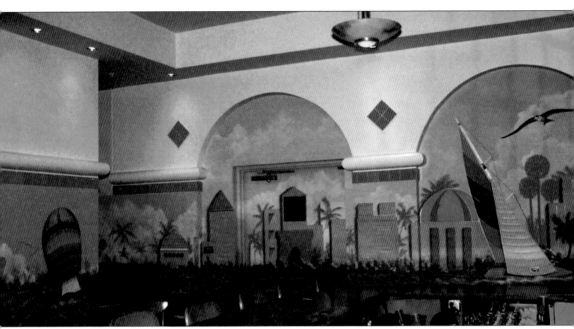

WELCOME TO PALM BEACH DETAIL. Gliding sailboats flowed through Concourse C at Palm Beach International Airport. In the summer of 1995, Sharon Koskoff and her father, Rubin "Papa Ruby" Koskoff, worked for 12 weeks painting two concessions that reflected South Florida's subtropical leisure sports and climate. Concourse B featured an underwater-themed coral reef (see page 27). The commissioned art welcomed travelers from around the globe. (From the archives of the Art Deco Society of the Palm Beaches [ADSPB], photograph by Sharon Koskoff.)

ON THE COVER: Mural artist and author Sharon Koskoff paints *I Heart Lake Worth* on a corner wall of the Nine Arch Mural Project at 1000 Lake Avenue on November 17, 2012. The arts initiative known as LULA was sponsored by the Lake Worth Community Redevelopment Agency (CRA) and led by marketing director Tracey Smith-Coffey. The multifaceted project was designed to revitalize blighted buildings, expand the downtown arts district, and strengthen the cultural community (see page 20). (From the archives of the ADSPB, photograph by Sharon Koskoff.)

MURALS OF THE PALM BEACHES

Sharon Koskoff

ARCADIA
PUBLISHING

Published by Arcadia Publishing
Charleston, South Carolina

Printed in the United States of America

Library of Congress Control Number: 2018930046

For all general information, please contact Arcadia Publishing:
Telephone 843-853-2070
Fax 843-853-0044
E-mail sales@arcadiapublishing.com
For customer service and orders:
Toll-Free 1-888-313-2665

Visit us on the Internet at www.arcadiapublishing.com

This book is dedicated to my avant-garde sister Cheryl Kerner, who inspired me to paint my first mural when I was 14. Also to my devoted father, Papa Ruby, who assisted me for more than three decades, and my mother, Shirley, for her encouragement and direction.

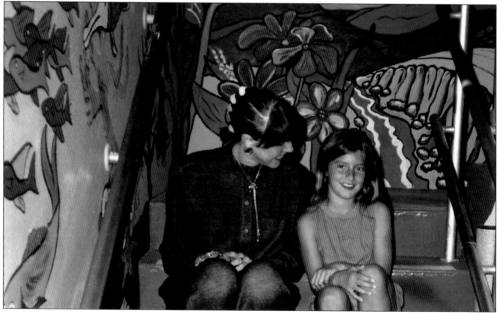

STAIRWAY TO THE STARS DETAIL. Armory Arts instructor Sharon Koskoff sits with 10-year-old artist Kelly Beuttner, one of many pupils who painted the escalating coral reef, landscape, sky, outer space, and planets mural installation. The staircase leads to the original South Florida Science Museum Observatory. The gala reception was held on June 12, 1992. (From the archives of the ADSPB, photograph by Ian L. Kerner and Stephanie K. Smith.)

CONTENTS

ACKNOWLEDGMENTS

Murals of the Palm Beaches contains 170 photographs that were chosen for their effort, significance, and sense of place. I salute the many individuals and institutions throughout Palm Beach County for their insight to commission public art. Tribute is paid to family, friends, volunteers, students, principals, assistants, supporters, and strangers who generously worked alongside me to create significant works of art. The book seeks to educate and visually entertain while documenting an abundant and prolific legacy of large-scale masterpieces.

Exceptional appreciation goes to my friend and mentor Linda Fleetwood, who after all these years is still here providing me with guidance, insight, and enlightenment beyond the writing of my second book.

I am truly grateful to Caitrin Cunningham, my Arcadia Publishing title manager, who had patience, compassion, and consideration when I needed it most and was always available for directives. Special thanks go to Tim Sumerel in production for handling every last detail.

Murals of the Palm Beaches collects and captures images of artworks long gone and is dedicated to the hundreds of participants who collaborated in their execution as well as a new generation of street artists who are dynamically changing the landscape we live in today.

All photographs are taken from the archives of the Art Deco Society of the Palm Beaches (ADSPB) and were photographed by Sharon Koskoff unless otherwise noted.

ABOUT THE AUTHOR

Sharon Koskoff is a public mural artist, graphic designer, educator, community organizer, children's advocate and preservationist. She is the founding president of the Art Deco Society of the Palm Beaches. Koskoff is sanctioned by the Florida Humanities Council Speakers Bureau, presenting tours and lectures on art and architecture throughout the state. The Cultural Council of Palm Beach County awarded her with the Ellen Liman Arts Educator Muse Award of Excellence in 2014. Visit www.ArtDecoPB.org and www.SharonKoskoff.com to learn more.

INTRODUCTION

Art is a reflection of society. When mankind created the first cave painting, murals were born. In 1933, the destruction of Mexican muralist Diego Rivera's *Man at the Crossroads* in New York City's Rockefeller Center foretold the ongoing controversy of freedom of expression and public murals. Public art found in the Palm Beaches echoes its diverse population. Our art history began in the early 20th century when murals were primarily decorative, historical, and mythological. Only a handful of these works remain in museums, government facilities, and private institutions. Murals played an important role in residential and commercial interior design for the wealthy; public murals, however, were associated with graffiti and vandalism.

Community Murals Arise
I grew up in Brooklyn, New York, and I began painting residential murals in 1968. I moved to Delray Beach, Florida, in 1985 and sought to paint exterior public murals full-time.

A renaissance of cultural education and awareness accelerated in the 1990s, creating artistic partnerships as a means to arts education and area revitalization in the Palm Beaches.

In 1994, artists, nonprofit organizations, and Palm Beach County public schools collaborated to form the Center for Creative Education (CCE). The Project LEAP (Learning through Arts and Education Partnerships) programming implemented artist disciplines through arts integration using the Florida State Sunshine Standards. As a muralist, I worked with teachers and classroom youth to paint interior and exterior school walls throughout the county.

Concurrently in 1993–1994, the MacArthur Foundation funded 12 community projects entitled the Neighborhood Artist in Residence Program (NARP), administered by the Cultural Council of Palm Beach County's grants director, Norree Boyd, for artists to use their expertise in underserved neighborhoods. Selecting Delray Beach, I proceeded to be the only mural artist on record to receive eight consecutive grants through 2002, branded the Community Mural Projects (CMP) I–VIII.

The City of Delray Beach had no guidelines or policies regarding public art and rejected the first mural proposal three times. I was forced to re-scout locations, gain stakeholder support, write petitions, and contend with officials. Despite all obstacles, I finally won approval in the underdeveloped Pineapple Grove Arts District that culminated in the *Love's Drug Mural*.

Simultaneously, in Lake Worth, city commissioner Retha Lowe worked with NARP grant recipient Roxanne Solomon and resident artists in order to paint the *Wall of Unity* mural in the Osborne neighborhood. Two more community volunteer opportunities arose when Maryanne and Bruce Webber painted the Art Shop mural and Gael Silverblatt and Laurie Rasmussen painted the Island Watersports building.

In 1995, Lake Worth had three murals and Delray Beach had only one. Compelled to even the score, I initiated two additional murals on the Parker's Kitchen building at West Atlantic Avenue for my second NARP grant with volunteers. Ultimately, after another highly publicized city debate, I earned site approval for the Community Mural Project II.

By my third NARP grant in 1996, I discovered county-owned public schools within city limits who welcomed the group mural projects, thereby circumventing bureaucracy. Atlantic Community High School, Delray Full Service Center, Pine Grove Elementary, and Spady Elementary School were the next recipients of the NARP Community Mural Projects, involving hundreds of volunteers and sponsors.

Public Art Entities Are Born
I became the first chairperson of the newly formed Public Art Advisory Board (PAAB) of Delray Beach in 2005. Similarly, Palm Beach County, Boynton Beach, West Palm Beach, and Boca Raton formed advisory and governing boards, whereas front-runner Palm Beach Gardens started in 1989. Art in Public Places (AIPP) programs and arts districts were established to integrate public art into architecture, infrastructure, and landscape environments. Regulations, guideline policies,

and local ordinances were passed requiring that a percentage of the city's municipal, and now sometimes private, development shall contribute to public art.

In the new millennium, principals observed that their students flourished academically from educational mural environments. As the economy soared and new construction developed, Palm Beach County public school consultant contracts were signed and hundreds of school walls acquired color. Mural contracts diminished following the great recession of 2008, as all forms of public art are endangered when circumstances change and the social climate fluctuates.

Street Art Today

A new mural movement, commonly referred to as "street art," became a nationally recognized phenomenon in 2009. Undervalued urban areas and declining historic districts were reconstructed and transformed into thriving destinations employing public art. Tony Goldman, owner of the Park Central Hotel in the South Beach Art Deco District, established Wynwood Walls in Miami as an open-air exhibition of international street murals. Goldman Properties has been the driving force behind the transformations of SoHo, the Upper West Side, and the Wall Street Financial District in New York City and Center City in Philadelphia.

In 2015, as social perceptions of street art murals began to change throughout the Palm Beaches, West Palm Beach took the lead, with CANVAS Outdoor Art Museum hosting international artists and the rotating antiestablishment movement of the Street Art Revolution spotlighting local artists. Seemingly overnight, a massive amount of public art murals, both temporary and revolving, saturated the walls of significant buildings.

Book's Structure by Theme

The six chapters of *Murals of the Palm Beaches* are laid out by theme and content. Larger-than-life murals or those painted on multiple surfaces are photographed in close-up detail. Murals can last forever or just one day. Although we have witnessed a wealth of new murals, many have disappeared with a simple coat of paint. This historical anthology documents our lost treasures while celebrating those that remain.

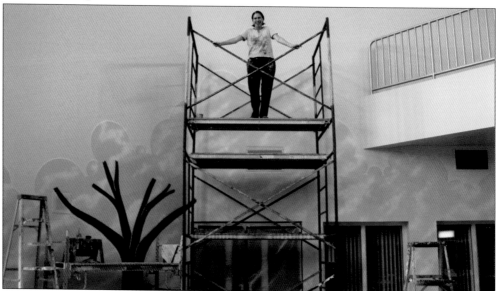

READING TAKES YOU AROUND THE WORLD IN PROGRESS. In the summer of 2008, Melvis Pender, principal of the new Westward Elementary School, and liaison Marsha Owens commissioned Sharon Koskoff to design the school's four-story octagonal atrium in West Palm Beach. While the project was still under construction, Koskoff ascended upon three levels of scaffolding. The mural installation includes three-dimensional mixed-media wall reliefs (see page 63).

One

FIGURATIVELY SPEAKING

ANGELS FROM THE VATICAN. The Invisible Made Visible: Angels from the Vatican, a blockbuster exhibition at the Norton Museum of Art, featured *Concert of Angels* by Giovanni Battista Gaulli (1639–1709). Artist Sharon Koskoff replicated the masterpiece and created a large-scale wooden cutout for the museum's opening reception on January 23, 1999. Dreyfoos School of the Arts students also worked to create an 18-foot mural entitled *Angels at Work*. Shirley Koskoff celebrates her birthday and poses as an angel.

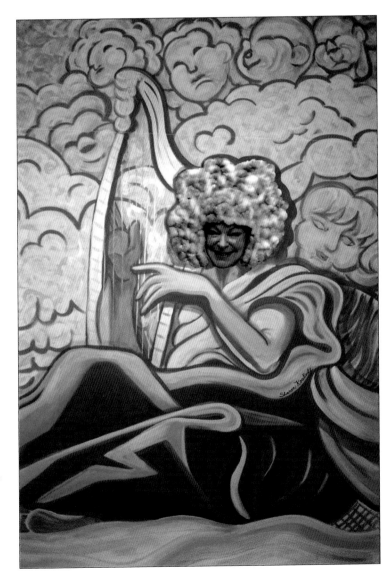

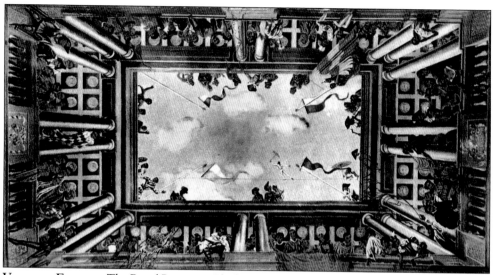

VENETIAN FESTIVAL. The Royal Poinciana Playhouse Celebrity Room ceiling mural in Palm Beach was created by Robert Bushnell in 1957. The 45-foot-wide, 30-foot-long mural took two years to complete and contained portraits of 125 international stars and local luminaries, including John and Jane Volk, Lilly Pulitzer, Clark Gable, Joan Crawford, Fred Astaire, and Yul Brenner. Preservationists Patrick Henry Flynn and, later, Pamela Stark Thomas unsuccessfully tried to save the theater, which went dark in 2004.

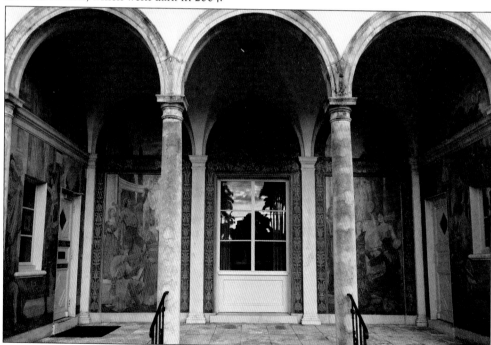

DRAMA, ART, MUSIC, & LITERATURE. The Society of the Four Arts Gallery Building (now the Gioconda & Joseph King Library) in Palm Beach displays four murals by classically trained artist Albert Herter (see detail on opposite page). In 1939, patron Mary Woodhouse commissioned the creation of the oil-painted murals on canvas. The two-story historic landmark designed by architects Treanor & Fatio underwent a $12 million renovation and expansion in 2017–2018.

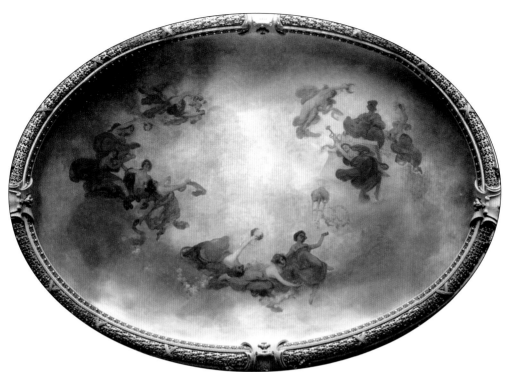

FLAGLER MUSEUM CEILING. In 1902, during America's Gilded Age, industrialist Henry Flagler hired architects John Carrère and Thomas Hastings to build a 75-room Palm Beach mansion for his third wife, Mary Lily Kenan. Shown is the central ceiling mural in the Grand Hall depicting Pythia, the priestess of the Oracle of Apollo at Delphi. Jean Flagler Matthews founded the Flagler Museum in 1960 to protect the mansion's collection, including 13 other ceiling murals. (Courtesy of the Flagler Museum.).

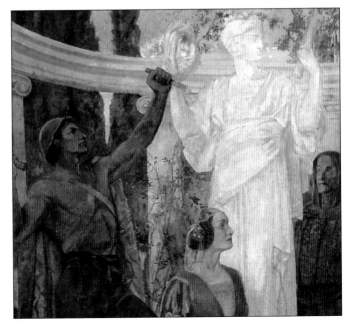

SOCIETY OF THE FOUR ARTS IN DETAIL. Albert Herter (1871–1950), who was assisted by Leonard Lester, trained in Paris with Jean-Paul Laurens and Fernand Cormon. While straying from popular Works Progress Administration (WPA) murals that reflected everyday life during the Great Depression, Herter painted within the highly aristocratic Beaux-Arts aesthetic. Industrialist Henry Flagler became a collector of Herter and hung a portrait entitled *Gloria* in his new Palm Beach mansion, now known as Whitehall.

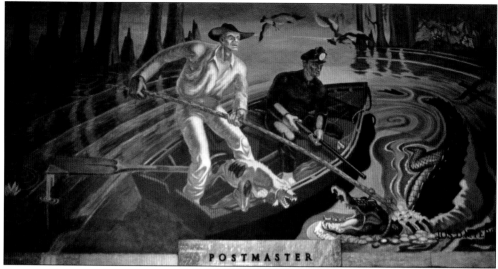

SETTLER FIGHTING ALLIGATOR FROM ROWBOAT. Joseph D. Myers painted this oil on canvas in 1946 for the downtown Lake Worth Post Office at 720 Lucerne Avenue. Controversy surrounded the public work from its inception in 1941. Squabbling over design and interruptions due to structural condensation led to the delay of Myers's mural installation and payment. The historical mural can be viewed on the west wall in the lobby during regular business hours.

KING SOLOMON'S TEMPLE I. During the mid-1980s, muralist Bernard Preston Thomas (1918–1994) researched the Old Testament and traveled to actual sites in Jerusalem. The 65-foot-wide, 10-foot-high mural follows 3,000 years of Middle Eastern history. The monumental mural depicts the First Temple, constructed by Solomon and Hiram, who furnished the architects and workmen. The mural is painted on the western wall of the fellowship room at the Scottish Rite Masonic

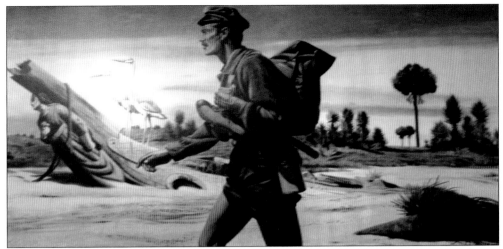

BAREFOOT MAILMAN DETAIL. The US Treasury Department Section of Painting and Sculpture commissioned Stevan Dohanos (1907–1994) to paint a six-panel tempera mural for the old Clematis Street post office. *The Legend of James Edward Hamilton, Barefoot Mailman* illustrates the story of the postman who died while crossing the Hillsboro Inlet through swamps, shipwrecks, and alligators on October 10, 1887. In 1985, the panels were relocated to the main Summit Boulevard post office in West Palm Beach.

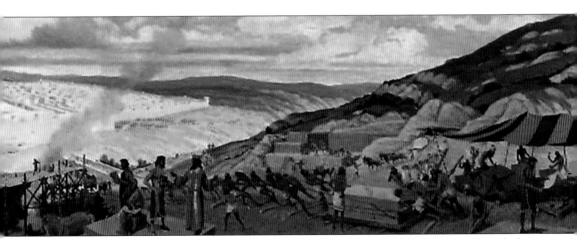

Center at 2000 North D Street in Lake Worth. Historian Janet DeVries has also identified a Bernard Thomas mural in the Boynton Beach City Library archives as *America the Beautiful*, a cyclorama that was in James Melton's Autorama, one of Florida's lost tourist attractions in the town of Hypoluxo. (Courtesy of the Scottish Rite Masonic Center.)

CENTENNIAL WEST PALM BEACH DETAIL. On October 1, 1994, Robert & Mary Montgomery Armory Art Center kids painted a six-panel mural measuring 24 feet wide by 8 feet high, led by Sharon Koskoff. The panels, on the facade of the Anthony Building on Clematis Street, celebrated the 100th birthday of West Palm Beach. The mural displays life along Flagler Drive in the 1890s and teaches children about their rich history. Intern Ryan Kerner poses in front of three panels.

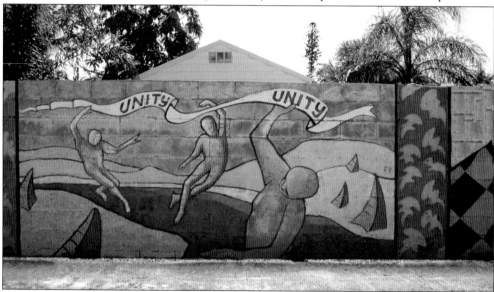

WALL OF UNITY DETAIL. In 1994, NARP artist Roxanne Solomon led the *Wall of Unity* on Wingfield Street in the Osborne section of Lake Worth. A video of artists painting 10-foot sections of the 1,000-foot-long, five-foot-high dividing structure was aired on PBS. The wall was built to segregate and originally called the "Wall of Hate," but the neighborhood mural now symbolizes peace.

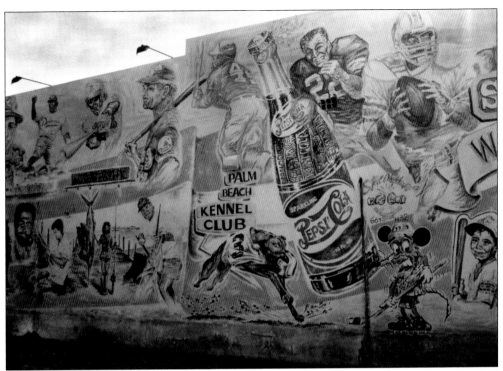

SPANKY'S WALL OF FAME DETAIL. The east wall of Spanky's Sports Bar was the first mural painted at 500 Clematis Street. In the late 1990s, R.J. Duffey intentionally painted washed-out primary colors of red, yellow, and blue to create a vintage appearance. New murals have since replaced the sports images, and the wall now serves as a temporary rotating public art site for contemporary street artists.

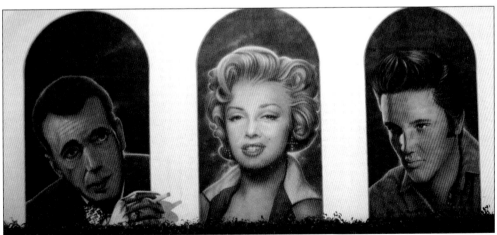

MOTEL OF THE STARS. Lake Worth artist Sami Makela painted Humphrey Bogart, Marilyn Monroe, and Elvis Presley in 1995 on the eastern facade of the New Sun Gate Motel on South Federal Highway. The Motel of the Stars features 32 rooms, all named and decorated with images of celebrities such as Picasso, John Lennon, Fred Astaire, Nina Simone, Ingrid Bergman, and, of course, those depicted in the arched murals.

LOVE'S DRUGS MURAL. In 1994, the Community Mural Project I was the first of nine NARP grants awarded to Sharon Koskoff by Norree Boyd of the Cultural Council of Palm Beach County. It involved 90 volunteers painting the 67-foot-wide, 14-foot-high Love's Drugs building (Dr. Fred W. Love's pharmacy) in multicultural Pineapple Grove. The Delray Beach Historical Society provided three iconic images. The community effort, which included a garden, resulted in a Main Street award from the National Trust for Historic Preservation for inspiring downtown revitalization.

LOVE'S DRUGS BEGINNING TO END. At left, in 1994, Sharon Koskoff (left) and Carolyn Zimmerman display the Love's Drugs mural sketch at Café Mocha on East Atlantic Avenue. At right, volunteers gather 12 years later at the Demolition/Reunion Party. From left to right are (first row) Bob Zaslow, Jeanne Fernsworth, and Sharon Koskoff; (second row) Donna Reppenhagen, Sue Keleher (1950–2012), and Terry Barnes. The building was demolished on June 2, 2006, to make way for parking at the Old School Square Garage (see page 95).

PARKER'S KITCHEN EAST WALL BEFORE. Parker's Kitchen is the corner soul food take-out restaurant at 700 West Atlantic Avenue in Delray Beach, owned by Donnie Dobson. In 1995, the Community Mural Project II was Koskoff's second NARP grant. The twin murals (see following image) rejuvenated the neighborhood. Koskoff removed the exterior encumbrances, resurfaced the walls, repaved the parking lot, and painted the facade of the building.

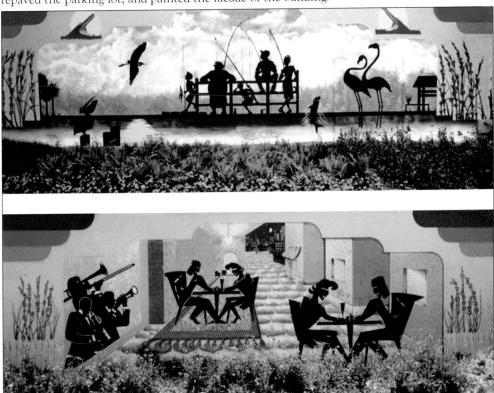

PARKER'S KITCHEN TWIN MURALS AFTER. Sanctioned by the Florida Sesquicentennial Committee and the Florida secretary of state, over 80 volunteers, including Helen Kelsey, Bill Gossett, Elizabeth Byron, Mark Peters, Carolyn Zimmerman, Arlene Devitt, Terry Barnes, son Nathan, and Daytron Witherspoon, worked on the project. *Silhouettes* balanced both sides of the building in homage to Van Gogh's Parisian cafés (bottom, east wall) and Don Blanding's book *Floridays* (top, west wall). The twin murals were lost during a construction makeover in December 2003.

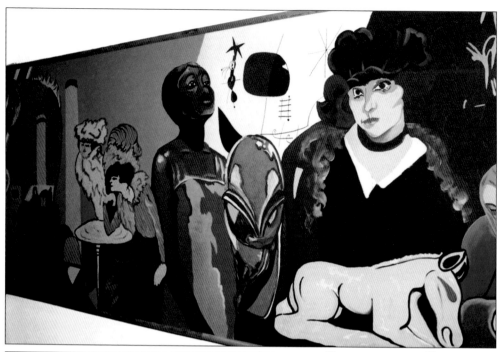

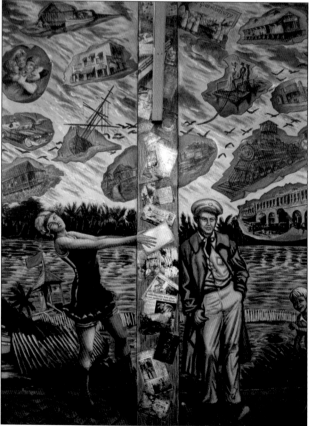

TREASURES OF THE PERMANENT COLLECTION DETAIL. The Norton Museum of Art expansion in 2000 celebrated its permanent collection with a youth-painted mural designed and led by Sharon Koskoff. The 18-foot-wide, 6-foot-high mural on canvas depicts significant holdings such as Picasso's *Au Café*, Chapin's *Ruby Green Singing*, Brancusi's *Mademoiselle Pogany II*, Miró's *Woman, Bird, and Star*, Matisse's *Portrait of Marguerite*, and an ancient horse from the Chinese collection.

FORGOTTEN MEMORIES DETAIL. In 1997, Anna Hardy Evans and assistants painted on the walls of Ocean Lumber in Delray Beach just west of Bru's Room. The art is hidden in Pineapple Grove off East Atlantic Avenue, entering north through Southeast Second Avenue. Floating in the sky are elements of notable images from the Palm Beaches.

LUSCIOUS LADIES IN RED DETAIL. Italian-born Palm Beacher Lino Mario Prebianca was a bohemian artist and trained architect who painted frescos on the ceilings of the Chesterfield Hotel dining rooms with sexy women, naughty cherubs, and leering goats. The once endangered mural has now become an icon of the famous island hotel known for celebrity guests and patrons. The swirling scarlet bodies were hand painted in exchange for Lino's bar tab.

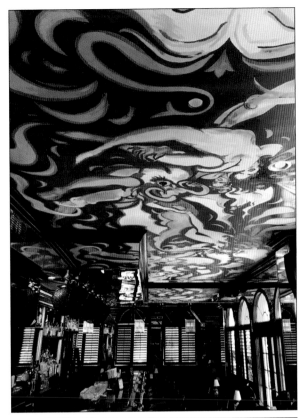

CEZANNE DETAIL. After viewing Sharon Koskoff's murals at Oscar's Restaurant in North Palm Beach, Dan Benda of Sunbelt Hotels hired her to paint this café scene at the Cezanne Club in the West Palm Beach Ramada Hotel (now Sheraton Hotel). The impressionistic namesake painting was created in 1994 on the stage wall as a backdrop for the musical entertainment at the late-night tavern.

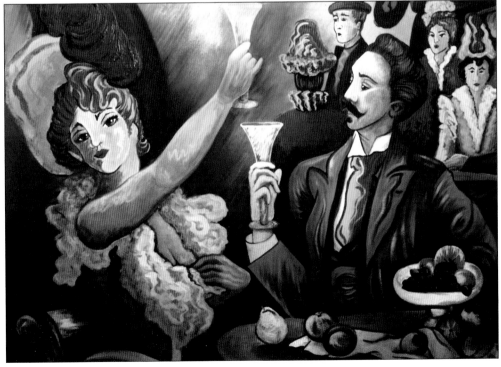

NINE ARCH MURALS DETAIL. Jennifer Chaparro's vintage bathing beauty adorns one of nine arched walls at 1000 Lake Avenue and North H Street in downtown Lake Worth. Other artists include Paul Slater, Patricia Levy, Eduardo Mendieta, Craig McInnis, Sharon Koskoff (see the cover caption on page 2), Astrid Mora, Judy Dempsey, and Steven Marino. The LULA Lake Worth arts project spans two sides of the structure.

STAGE LEFT THEATRE. Sharon Koskoff led the Art Deco mural project at the Madsen Center Shuffleboard Courts of Boynton Beach in October 2013. Ryan Kerner assisted in painting the transformed courts structure. Tracey Smith-Coffey of the Boynton Beach Community Redevelopment Agency (CRA) also included a second mural by Jennifer Chaparro and a third by Craig McInnis (see opposite).

HOWLEY'S DINER. In 2009, mural artist Amanda Valdes painted her wide-eyed signature images on the north wall of the Mid-Century Modern landmark at 4700 South Dixie Highway in West Palm Beach. The Sub-Culture Group, co-owned by Rodney Mayo and Sean Scott, commissioned the artwork, which replaced a black-and-white 1950s design painted by Lynelle Forrest in 2004. Valdes also has murals in Northwood Village, the home of the Center for Creative Education and an up-and-coming mural district.

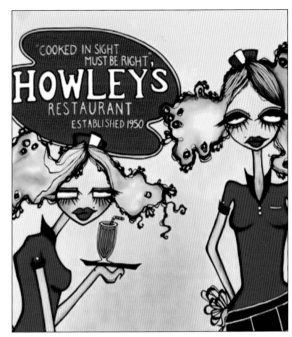

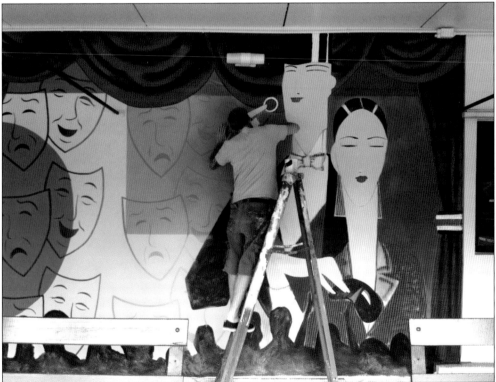

STAGE LEFT IN PROGRESS. Artist Craig McInnis paints the entry wall to a newly converted community theater in Boynton Beach. The red stage curtains are repeated around the building, now called the Boynton Beach Playhouse. McInnis is a freelance artist who is also the creative director for the haunting Fright Nights of the South Florida Fairgrounds.

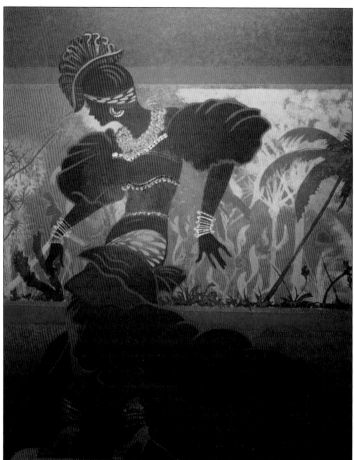

CASTAWAYS FLORIDIANA. On April 6, 1997, the Family Golf Center on Belvedere Road celebrated the opening of the Castaways Bar & Grill with Sharon Koskoff's Caribbean reggae-and-calypso-influenced murals painted throughout the restaurant. A detail of a dancer painted with a glitter necklace is shown. Although the decadent reception was well attended, the dining hall closed within the year.

THE GARDEN DANCERS. During the fall season of 2008, artist in residence Sharon Koskoff and volunteer Lidia Golovan worked with youth at the historic Osborne Center's For the Children after-school program, founded by Reginale Durandisse in 1999. Exterior walls, interior hallways, three classrooms, and two bathrooms were painted with different themes, such as planets, a coral reef, rainbow landscapes, and visual and performing arts.

Two

AQUATIC ADVENTURES

CORNELL CORAL REEF SIGNATURES. On June 27, 2008, Madison Lynne Saldivar (left) and her grandmother Gloria Rejune-Adams, Cornell Museum of Art and American Culture director, sign their names onto *Cornell Coral Reef,* a marker-painted mural designed by Sharon Koskoff (see page 26). Gloria was the museum's first director, serving from February 1, 1989, until her retirement on April 30, 2014.

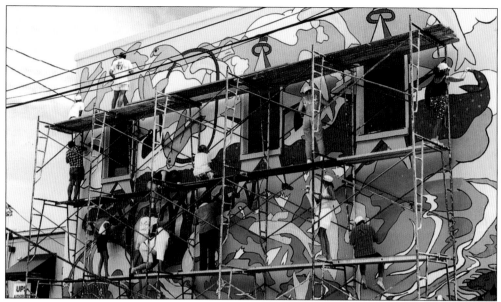

WHERE THE TROPICS BEGIN IN PROGRESS. For a week in July 1994, Gael Silverblatt and Laurie Rasmussen gathered 20 Lake Worth volunteers at 728 Lake Avenue to create the 25-foot-high, 40-foot-wide mural symbolizing optimism and revitalization. Lasting for 18 years and facing Lucerne Avenue, the tropical mural was painted on the rear of the Island Watersports building.

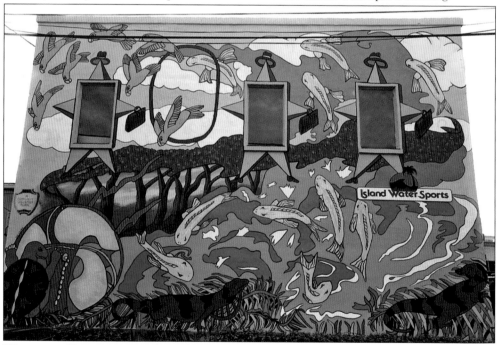

WHERE THE TROPICS BEGIN. This title refers to the City of Lake Worth's motto. Fish are jumping, parrots are flying, royal poincianas are blooming, and tin men with brief cases bring prosperity, as they see renewed hope in Lake Worth's future. The city commission hoped this would be the start of more murals and recommended employee incentive programs for participation. The landmark was demolished in December 2012. (Courtesy of Gael Silverblatt.)

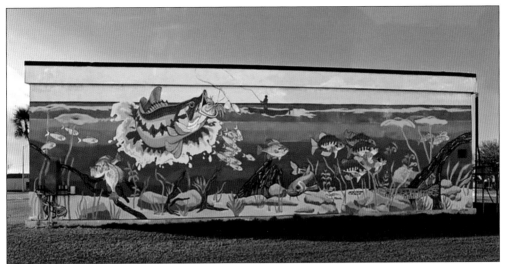

GOING FISHING. Kimberly Sovinski, curator of education at the Norton Museum of Art, worked with 100 underserved after-school youth and Loli Blanchard Santiago of the Glades Youth Discovery Center in 1994. The teens painted the north wall of the Belle Glade Library, located on State Road 80 at Dr. Martin Luther King Boulevard, to capture the essence of the Everglades and Lake Okeechobee. (Courtesy of Kimberly Sovinski.)

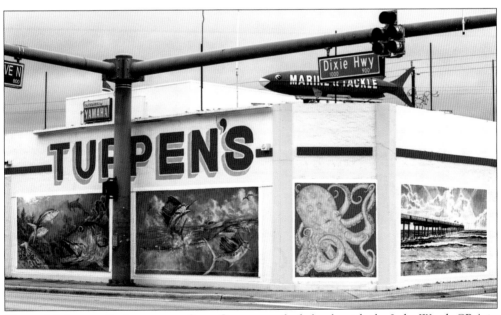

TUPPEN'S MARINE. Business owner Steve Sprague worked closely with the Lake Worth CRA in 2014, hiring three mural artists to paint the walls of the intersection at North Dixie Highway and Tenth Avenue North. From left to right, two murals painted by Tom D'Auria depict yellowtail and mutton snappers and sailfish. The third, corner mural, painted by Chrisanthy Vargo, features a pink octopus. The final mural, painted by Joseph Dzwill, illustrates a fishing pier.

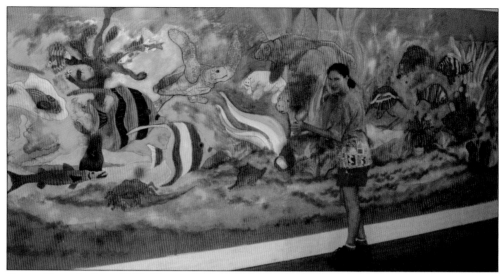

CORAL REEF. In June 2008, Sharon Koskoff and young students created a mural using markers, not paint, on the west wall of the Children's Gallery of the Cornell Art Museum of Old School Square. A five-foot roll of canvas 18 feet wide was used to illustrate the tropical fish for a six-month exhibition. When the show was over, the coral reef canvas was removed, rolled up, and preserved for future exhibitions.

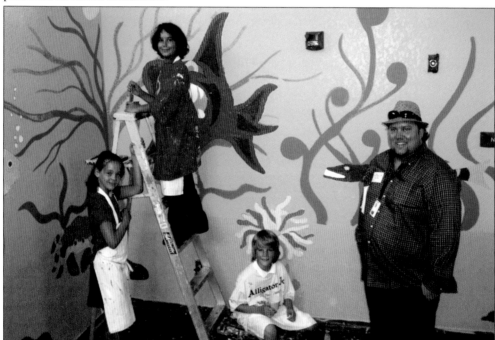

ART, DRAMA, AND LITERACY IN PROGRESS. Plumosa School of the Arts (SOA) students were inspired after reading Delray Beach author Frank McKinney's book *Dead Fred, Flying Lunchboxes, and the Good Luck Circle*. Sharon Koskoff worked with art students (left to right) Madeline Harris, Marcos Sanchez, and David Reynolds, who painted images referencing the book and later presented a theatrical performance. On the right is David DiPino, *Sun-Sentinel* writer and photographer, on May 12, 2012.

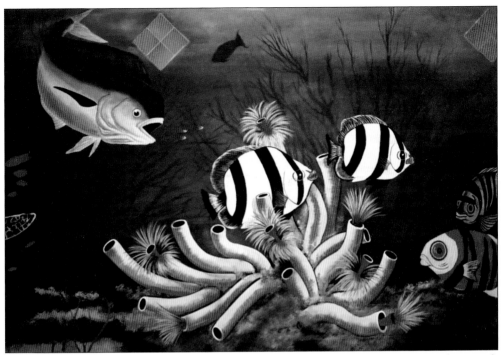

PALM BEACH INTERNATIONAL AIRPORT CORAL REEF DETAIL. Concourse B is Palm Beach International Airport's busiest terminal and one of two concessions painted by Sharon Koskoff and Papa Ruby in 1995. Murals on Concourses B and C (see page 2) were commissioned by Timothy Bannigan of CA1 Services. The interiors were demolished in 1999, when new management renovated the international gateway.

HOME SAFE AQUARIUM DETAILS. The two photographs show details of the 81-foot subaquatic mural painted by Sharon Koskoff, Papa Ruby, and Charles Loomis in 1997 on the exterior walls of the Home Safe children's courtyard. Home Safe is a nonprofit organization in Lake Worth that provides comprehensive programs protecting victims of child abuse and domestic violence. Two additional murals were created for the interior lobby and hallway (see page 58).

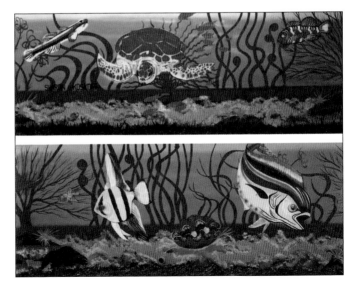

SCIENCE DISCOVERY CENTER DETAIL. South Florida Science Center and Aquarium's chief operating officer Kate Arrizza commissioned Sharon Koskoff to design a colorful environment and paint the new Early Childhood Water Room, equipped with a wall-sized Lite-Brite play area and giant water table. Youth are featured at the May 2015 opening reception for the 76-foot Everglades and coral reef murals, sponsored by PNC Bank.

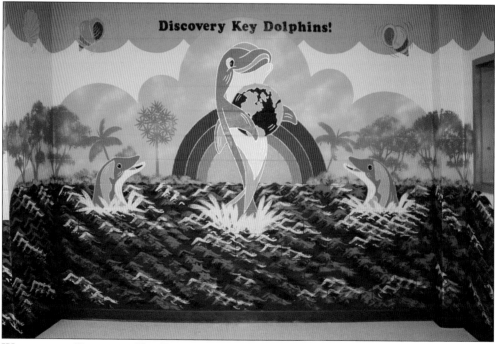

WELCOME TO DISCOVERY KEY DETAIL. In April 2005, Papa Ruby and intern Matthew Brown assisted Sharon Koskoff in the painting of three murals at Discovery Key Elementary School in Lake Worth (see page 60). The project was sponsored by the PTA with Kimberly Briard under Principal Steve Sills. The administration lobby featured the school's dolphin mascot holding the earth, with a yellow border of tropical shells wrapping around four walls.

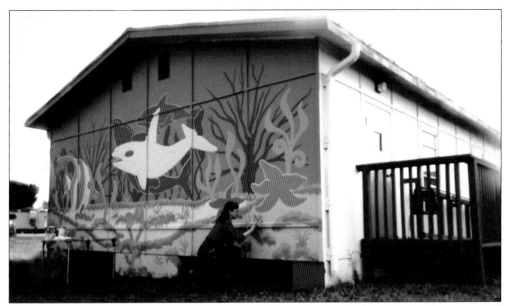

A SCHOOL OF FISH. For the NARP grant in 1999, the Community Mural Project VI, Sharon Koskoff signs one of seven temporary portables painted at the Montessori magnet S.D. Spady Elementary School. In 2001, Koskoff returned to the classrooms and painted four more structures for a total of 11 murals facing Lake Ida Road in Delray Beach. After-school youth, parents, and Girl Scout Troop No. 004 worked with volunteers under principals Denise Doyle and Martha O'Hare.

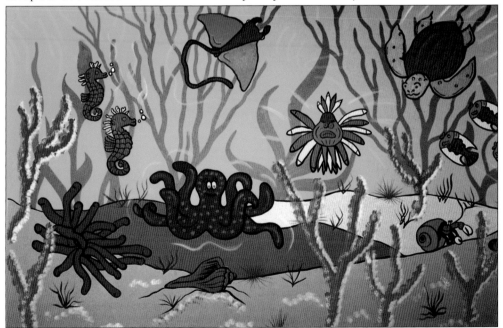

THE FOOD CHAIN. In May 1996, Project LEAP artist Sharon Koskoff worked with 90 kindergarten students on the campus of the original Palm Beach Public School to create an 18-foot coral reef with teachers Susan Campbell, Nancy Hewitt, Carrie Levine and in-school coordinator Darinda Teeling. A rainforest mural was also painted for the curriculum-based arts integration program under Principal Marilyn Brady. The building was modernized in 2005.

SWIMMING FREELY DEPARTMENT OF JUVENILE JUSTICE. In September 2013, detained teens held at the State of Florida Department of Juvenile Justice (DJJ) in West Palm Beach were recipients of a Very Special Arts (VSAFL.org) mural program that enlisted Sharon Koskoff with her intern Key Russell. Koskoff also worked with incarcerated youth in Port St. Lucie DJJ to create a tropical paradise mural in April 2008, both under the command of DJJ superintendent Kevin Housel.

ENVIRONMENTAL RESOURCE MANAGEMENT (ERM). In September 1995, ERM's Mike Greenstein and 10 employees painted two hallways measuring 200 feet each; horizontal bandings connected the hallways with overlapping coral reef creatures and ecofriendly elements. Sharon Koskoff volunteered to lead the project. ERM was at 3323 Belvedere Road, across from Palm Beach International Airport, and has since relocated to the new county headquarters on Jog Road.

Three

FLORA AND FAUNA

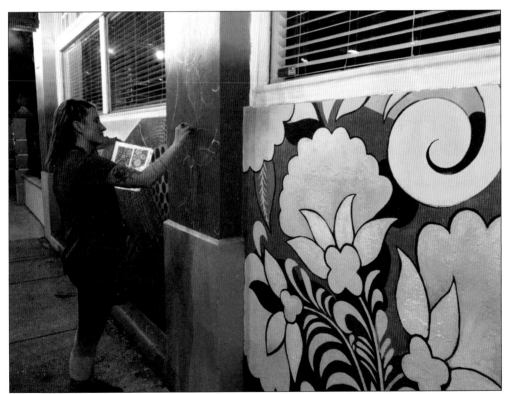

EVERNIA STREET DETAIL. Latasha "Tasha B" Blymier Spencer paints a West Palm Beach commercial building on South Dixie Highway at Evernia Street in January 2017. Latasha was a longtime student of Koskoff's Armory Art Center classes in the 1990s. She continued to study art at Bak Middle School and Dreyfoos School of the Arts. Tasha B's *Movie Star* mural at City Diner, owned by Jo Larkie, is also on South Dixie Highway.

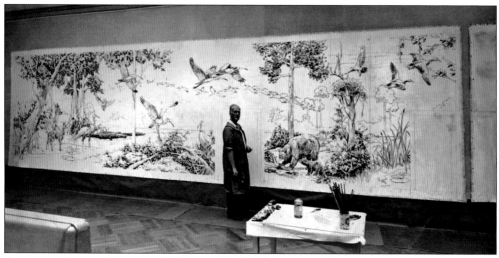

CLEWISTON INN IN PROGRESS. J. Clinton Shepherd (1888–1975) was the director of the Norton Gallery & School of Art from 1941 and 1946 and was known as a sculptor and painter. He is best known in Palm Beach for his murals and portraits at the Everglades Club and Maurice's Restaurant. Shepherd in shown working on the underpainting of the 784-square-foot, 360-degree wildlife mural on canvas prior to installation at the Clewiston Inn's Everglades Lounge & Bar in Hendry County. (Courtesy of A. Clemmer Mayhew III.)

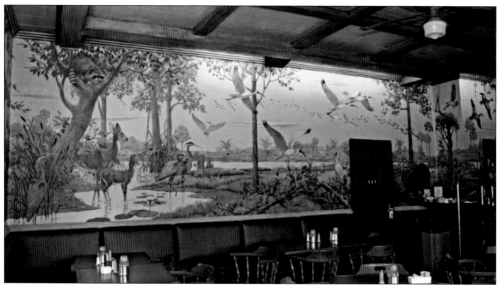

CLEWISTON INN DETAIL. The installed Everglades mural celebrates the flora and fauna of Lake Okeechobee. Shepherd used artistic license and painted the animals in unrealistic scale. The Clewiston Inn, built by US Sugar in 1938, was designed in Classical Revival style by Palm Beach architects L. Phillips Clarke and Edgar S. Wortman. The inn, listed in the National Register of Historic Places, continues to display the epic mural. (Courtesy of Linda Stabile.)

LOST TRIBE DETAIL. City planner James Borsos proudly displays the Everglades mural he painted with Sharon Koskoff on the second floor of the Cornell Museum of Art and History. The 24-foot-wide mural on canvas was painted to coordinate with the upcoming exhibit in February 2009. On the opposite wall, a three-dimensional Seminole chickee hut mural was also commissioned by Joe Gillie, executive director of Old School Square.

LOST TRIBE UPCYCLED. In June 2011, the Puppetry Arts Center of the Palm Beaches, led by Jo Janeen and William Timmis, moved from West Palm Beach to the Arts Garage building in Delray Beach's Pineapple Grove. Koskoff's *Lost Tribe* mural on canvas was reinstalled and site-specifically expanded. The great blue heron, flamingoes, and egrets were a perfect fit for the puppet theater's new home. After four years, the mural was once again rolled up.

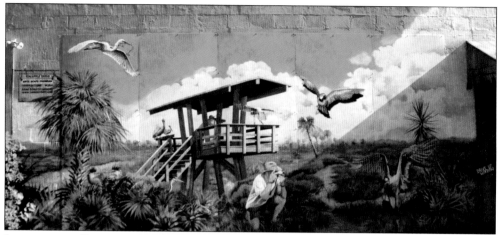

LOXAHATCHEE OBSERVATIONS. Artist Dana Donaty painted aluminum panels and installed them onto the north wall of the Delray Camera Shop in 2007. Paint was also applied to the uncovered surfaces to complete the 75-foot-wide, 15-foot-high wall. *Observations* was commissioned by Gene Fisher of the Pineapple Grove Main Street program. In 2012, Palm Beach County AIPP contracted Donaty to create a mural installation at the Head Start School in West Palm Beach.

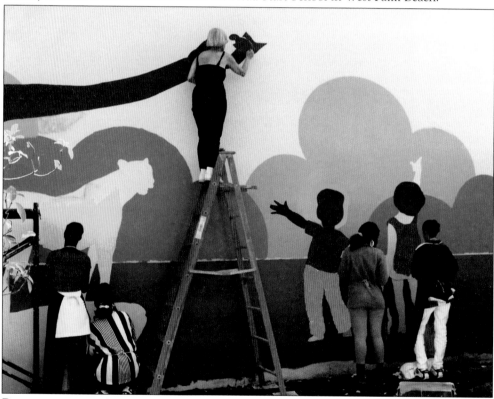

REACHING FOR THE STARS IN PROGRESS. Sharon Koskoff's third NARP grant, the Community Mural Project III at the Delray Full Service Center, highlighted the school's cheetah mascot. Cuban-born Boca Raton artist Margarita "Maggie" Jourgensen paints high up on a ladder with students. Maggie is best known for her cutting-edge mixed-media assemblages and has volunteered on many of Koskoff's projects.

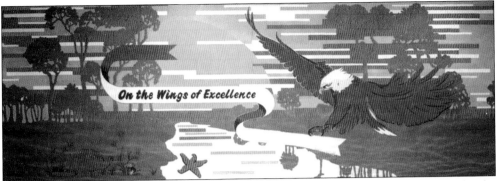

ON THE WINGS OF EXCELLENCE DETAIL. In April 1998, Eagles Landing Middle School, under the leadership of Principal Bonnie Fox, had six murals (see page 59) painted by Sharon Koskoff, Papa Ruby, and Charles Loomis. The new construction in west Boca Raton, with concrete block walls protected with oil-based paint, was then coated with primer in order to use water-based acrylic paint, the muralist's preferred medium.

PINE LANDSCAPE WITH WILDLIFE DETAIL. In 2004, Principal Diane Conley of Greenacres Elementary School requested Sharon Koskoff and Papa Ruby paint a *Kids Around the World* mural for the administration lobby and a coral reef hallway that morphed into a pine landscape with a Florida panther. Koskoff also painted two bulldogs, the school's mascot, just for fun.

EAGLE AND THE RAINFOREST IN PROGRESS. In the summer of 2002, Julia Ewart received a Lincoln Award from the Trinity College Illinois Scholarship Program to travel from Hartford, Connecticut, to the Palm Beaches for a three-month internship with Sharon Koskoff. Ewart worked seven days a week with Koskoff and is photographed at Boca Raton Elementary School painting the rainforest animals in secondary colors of green, purple, and orange.

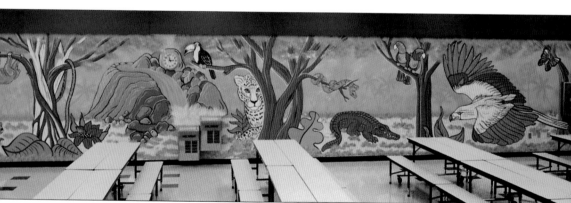

EAGLE AND THE RAINFOREST FINAL DETAIL. Papa Ruby, Julia Ewart, and Sharon Koskoff painted the 83-foot mural when school was out. The mural wrapped around the cafeteria across fire extinguishers, wall outlets, and a two-level drinking fountain, which was painted into a waterfall. Principal Mary Smith also had an astrophysical mural painted in the main stairwell lobby with the school's motto, "Where the Stars Shine Day and Night."

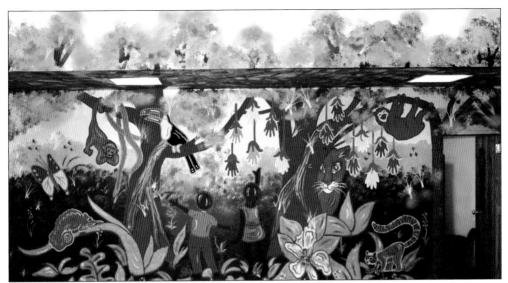

THE GIVING TREE HELPING HANDS. In May 1998, the Cultural Council of Palm Beach County funded an artist in residence grant for Sharon Koskoff to work with teachers Lenae Breger (Educator of the Year finalist) and Kim Mazauskas of Del Prado Elementary School in Boca Raton. At-risk fifth-graders worked hand in hand with kindergarteners to create a cafeteria mural, *The Giving Tree*, that grows helping hands. The student mural adorned the school walls and soffit until 2015.

STARFISH SAVERS MAKING A DIFFERENCE DETAIL. Sharon Koskoff and Papa Ruby painted eight murals (see page 65) during the construction of the new Odyssey Middle School in west Boynton Beach, supervised by Principal Bonnie Fox, in the summer of 2001. Students can empathize with the out-of-water endangered starfish, who are being thrown back and saved one at a time.

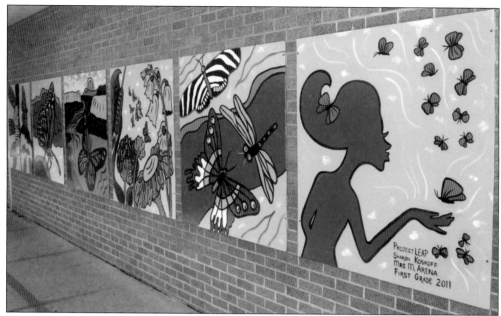

MONARCH BUTTERFLY MIGRATION. Marcia Arena's first-grade class worked with Project LEAP artist Sharon Koskoff to learn about the migration of the monarch butterfly. Simultaneously occurring was the marriage of British heir to the "monarchy" Prince William and Catherine Middleton on April 29, 2011. Welcomed by Principal William J. Fay Jr., six 4-foot-square panels reflecting the life cycle of nature were installed at the Banyan Creek Elementary School entrance in Delray Beach.

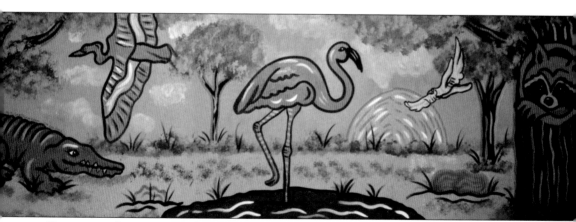

EVERGLADES INCLUSION AT HIDDEN OAKS. VSAFL.org is a Florida state program that trains artists to work with disabled populations. In April 2010, VSA artist Sharon Koskoff worked with 12 students in Harold "Mr. Hal" McCue's class for students with special needs and intellectual disabilities, acknowledged as inclusive instruction. The three-panel mural hangs in the main hallway of Hidden Oaks Elementary School in Boynton Beach and features Mr. Hal-igator, Harry Heron, Pinky Flamingo, and Rocky Raccoon.

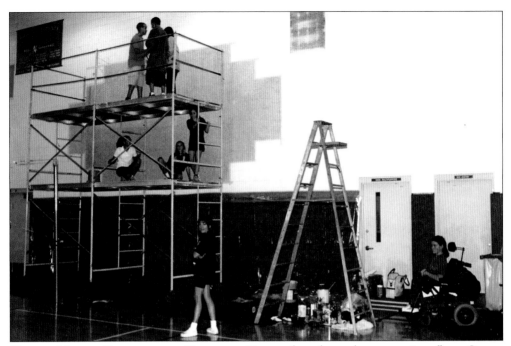

CARVER MIDDLE GYMNASIUM IN PROGRESS. Twenty feet above the gymnasium floor, Carver Middle School students paint a concrete block wall mural in the CCE after-school program called CADRE, led by Sharon Koskoff in March 2000. Tropical Ladders and Lifts donated the two-tiered scaffolding, while a student participating from a wheelchair manages the ground-floor mural supplies.

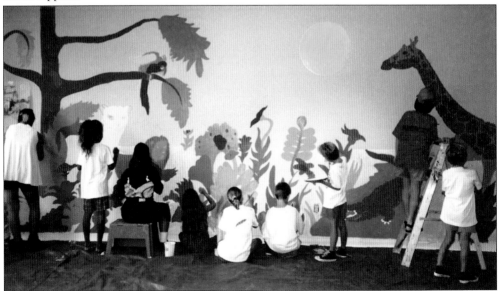

HEALING FRIENDS IN PROGRESS. Mary Alice Pappas of Good Samaritan Hospital and Sunny Bippus Interiors commissioned Sharon Koskoff and her Armory Art Center students, including Lara Boner, Lindsey Webb, and Spencer Gall, to paint the north wall of the children's wing at the Good Samaritan Hospital Pavilion in West Palm Beach. The new five-story atrium addition opened on June 26, 1995.

ODYSSEY MIDDLE LANDSCAPE DETAIL. Delray Beach mural artist Helen Kelsey was commissioned to paint 14 restrooms at Odyssey Middle School in 2002. Kelsey studied at the Pratt Institute in New York and works with many interior designers. She is known for decorative art, trompe l'oeil, and wall glazes. Helen Kelsey also painted the Parker's Kitchen twin murals with Sharon Koskoff in 1995 (see page 17).

ANDY WARHOL ARMORY ARTS BALL DETAIL. Sharon Koskoff designed six fundraising arts balls for the Armory Art Center from 1995 to 2000. On November 18, 1998, she painted the Armory's restrooms for the Andy Warhol Factory–themed gala event to spruce up the Art Deco structure; the paintings remained for several years until the restrooms were remodeled. The National Guard Armory building was built in 1939 by William Manly King and is registered with the National Trust for Historic Preservation.

INSIDE MY VERY OWN TREEHOUSE DETAIL. Connor Moran Children's Cancer Foundation, now in Jupiter, was located on 5601 Corporate Way in West Palm Beach. The nonprofit brings happiness and hope to children affected with cancer and other life-changing illnesses. Sharon Koskoff volunteered to create a treehouse mural that enveloped the closet-sized office walls and completely transformed the space in April 2000.

TROPICAL RAINFOREST AT THE ZOO. More than 25 students, including Dominick Bedasse, from Koskoff's art class at the Armory Art Center, completed a 40-panel construction barrier mural on Valentine's Day 2001. The Palm Beach Zoo at Dreher Park was under construction for several years, bringing to life the Harriet W. and George D. Cornell Tropics of the Americas. The temporary plywood mural measures 8 feet high by 160 feet wide.

LOGGERS RUN *FOREST FRIENDS* DETAIL. Loggers Run Middle School in west Boca Raton had three murals painted by Papa Ruby and Sharon Koskoff. The first two mural themes were coral reef and sailboat designs selected by Principal Judith Klinek. The Koskoffs came back in the summer of 2001 with Principal Debra Johnson and continued with a Paul Bunyan–styled logging landscape. The blue letters on the trees represent the initials of Loggers Run.

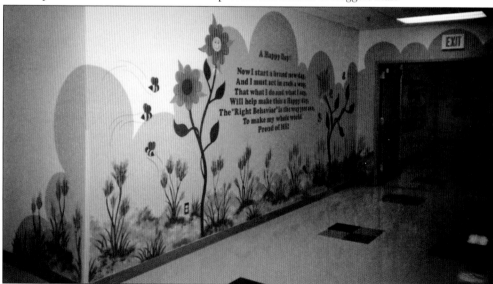

A HAPPY DAY! School district construction consultant Marsha Owens and Belvedere Elementary School principal Sandra Brown commissioned Sharon Koskoff and Papa Ruby to paint seven murals in August 2003 in the new administration lobby, media center, hallways (see page 79), and cafeteria. The artists came back to paint the school's daily mantra for the school's opening dedication on April 14, 2004. Principal Diane Mahar continues to maintain the artworks and poetry wall of written words.

Goats, Pigs, Chickens, and Sheep Detail. On December 3, 1995, Sugar Sand Science Park opened to the Boca Raton public, hand built by a community of volunteer artists, engineers, and scientists. Artist Sharon Halupka-White worked with Sharon Koskoff to create mural panels in the Tot Lot area. The farm animals are placed in a hidden crawl maze that only toddlers can discover. Halupka-White is the lead sculptor of public architectural ornamentation at Pineapple Grove Designs in Boynton Beach. (Courtesy of Patricia Lynn.)

Growing Peacefully Detail. In August 2007, Marsha Owens contracted Sharon Koskoff to paint the administration lobby and four additional environments, including the media center, the cafeteria (see page 45), the science room, and the math room of Barton Elementary School. Principal Dr. Aurora Francois wanted to represent peace, realized with a dove, and maturity, depicted by the life cycle of plants. Papa Ruby Koskoff assisted in painting the Lantana school.

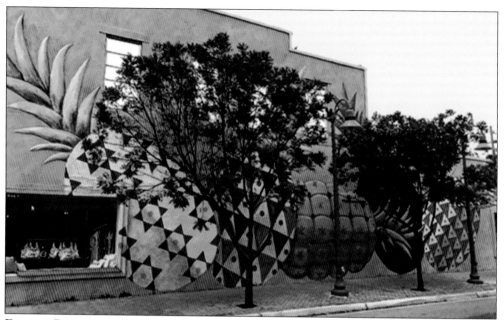

DANCING PINEAPPLES. In 2008, Anita Lovitt designed the mural at the gateway of the Pineapple Grove Historic Arts District on Northeast Second Avenue in downtown Delray Beach. Fort Lauderdale artist Brent Miller painted the mural with Lovitt on a privately owned commercial building. The arts lease of the wall expires after 10 years.

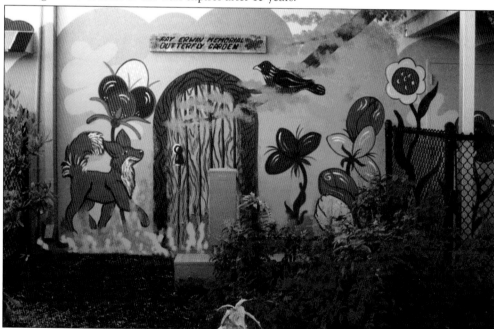

THE SECRET GARDEN DETAIL. Fifth-grade teacher Susan Jones and her class of 16 students painted the walls of the Irwin Rae Memorial Garden with Project LEAP artist Sharon Koskoff at Washington Elementary School. The 60-foot mural was created in honor of the teacher who died on his way to work. After the students read *The Secret Garden* by Frances Hodgson Burnett, the butterfly garden and mural were created in October 1997.

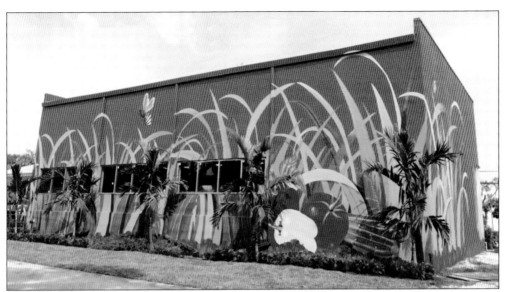

FARM FRESH. Bedner's Farm Fresh Market is located in the Artists Alley warehouse district, an enclave of Pineapple Grove, at 381 Northeast Third Avenue, Delray Beach. In an effort to revitalize the area and connect with aesthetic sensibilities, Claudio Camilucci designed the concept for the fresh produce–themed mural. It was executed by Rye Quartz of San Francisco's The Mural Co. in January 2016; the artist also painted *The Kiss* mural on the opposite building.

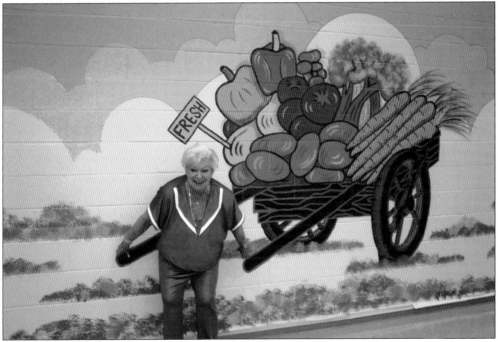

FRESH AND HEALTHY DETAIL. In 2008, Shirley Koskoff shows her sense of humor while interacting with the vegetable cart painted on one of the cafeteria walls at Barton Elementary School in Lantana. An old-fashioned wishing well scene adorning the opposite wall cleverly encompasses four drinking fountains. The two front stage walls are embellished with fruit trees. Good nutrition is the lesson for students. (Courtesy of Ian Lane Kerner.)

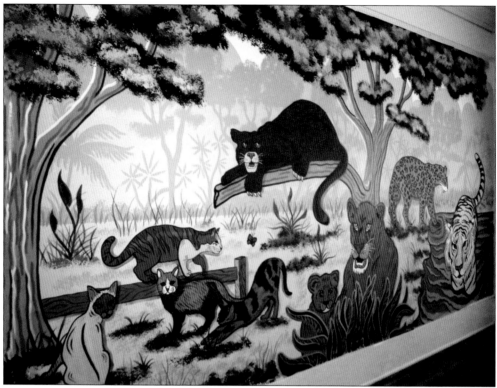

CATS! THE MURAL DETAIL. Colors of the rainbow contrast a monochromatic gray background on the wall of the Children's Interactive Gallery at the Cornell Museum of Art. Sharon Koskoff, assisted by James Borsos, created the mural in conjunction with the *Wild to Mild* cat exhibit. It was on display from October 7, 2010, until February 28, 2011. The 8-foot high, 25-foot-wide canvas included everything from lions and tigers to domestic cats.

MANY COLORS, MANY FACES DETAIL. In the spring of 2010, health coach Kenneth Zeno and Sharon Koskoff worked with students at Orchard View Elementary School in Delray Beach to combine environmental awareness with multiculturalism. Two 53-foot murals, a rainbow-faced tree and a coral reef, were painted along with three-dimensional hanging butterflies and fish. Principal Kathleen DePuma requested the word *welcome* be scribed in five languages on the administration office doors.

Four

EARTH, ABOVE, AND BEYOND

HAPPINESS IN THE SUN IN PROGRESS. Mural artist Steve Brouse of Buffalo, New York, pulls off masking tape on the courtyard walls of Pine Grove Elementary School at the *Paint Up Pine Grove* volunteer event on the hottest day of the year, August 1, 2014 (see page 61). Principal Joe Peccia surprised students when they returned from summer recess with 10 new Delray Beach–themed murals by *Art in the Alley* artists led by Sharon Koskoff. Brouse teaches art with the Center for Creative Education after-school program and has worked on multiple public art projects for the City of West Palm Beach, including the Old Northwood Historic District.

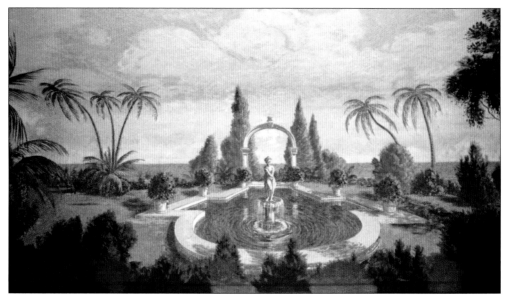

BOYNTON BEACH WOMAN'S CLUB. In 1925, the structure at 1010 South Federal Highway was built by architect Addison Mizner. The club was placed in the National Register of Historic Places in 1979. During the 1980s, Bernard Thomas's students painted this fountain as scenery on the ballroom stage. Thomas also painted the *History of Boynton Beach* mural in the club and *After the Last Supper* in the First United Methodist Church at 101 North Seacrest Boulevard.

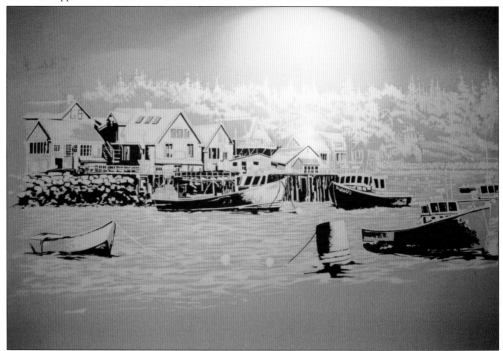

PERFECT MAINE. The monochromatic seascape on the corner of Southeast Second Avenue at East Atlantic Avenue was painted for the short-lived site of Linda Beans Maine Lobster in downtown Delray Beach and was illuminated at night. Castle Florida Building Corporation was the general contractor that built out the restaurant in 2011. (Courtesy of Sandi and Gerry Franciosa.)

SEA OF GALILEE DETAIL. Barnett "Barney" and Frieda Guthartz envisioned their ribbon-cutting for the Galilee L'Chaim Retirement Village at 4685 Haverhill Road in West Palm Beach. Sharon Koskoff and Papa Ruby, assisted by Chicago artist Paul Meyer, worked for 12 weeks painting Judaic murals on 200 feet of the walls of the luxury apartment complex's multipurpose room. Although the grand opening took place on February 26, 1995, the dream was unrealized.

NATURAL FOREST STAGE. The Palm Beach Zoo at Dreher Park built a 44-foot stage to accommodate live animal presentations in March 2002. Sharon Koskoff and Papa Ruby painted muted, natural colors on 11 vertical panels to blend into the jungle environment. Small door openings were enhanced to allow the animals to make a grand entrance. The stage was heavily damaged during Hurricane Wilma in 2005.

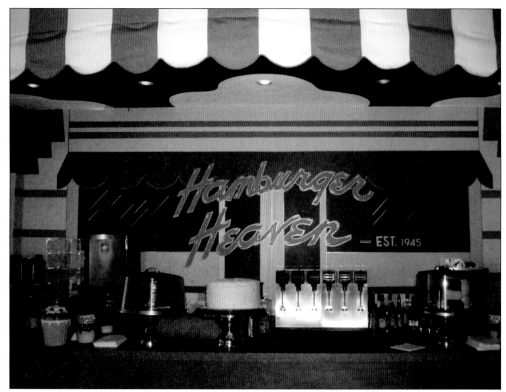

HEAVENLY REMAKE DETAIL. During the holiday season of 2012, Ryan Kerner and Ricardo Cruz-Griffis assisted Sharon Koskoff in painting a mural reminiscent of the original Hamburger Heaven restaurant of Palm Beach. The Art Deco facade was recreated in vintage sepia tones behind the soda fountain. Owner Cynthia Rosa and general contractor Paul Davis were disheartened when the new Clematis Street location in West Palm Beach closed in April 2015.

CAT AND MOUSE DETAIL. Sharon Koskoff joined Delray Beach community foot patrol officers Jim Horrell and Javaro Sims for a beautification effort on West Atlantic Avenue in the summer of 1995. The building at Southwest Twelfth Avenue was painted gray, and Koskoff designed eight large-scale Addison Mizner–styled windows for the east and west walls, creating a sense of architecture. A whimsical cat and mouse were painted in one window only.

DOWNTOWN SHOPS IN PROGRESS. Maryanne and Bruce Webber owned the Art Shop in a historic Art Deco building at 705–711 Lucerne Avenue in downtown Lake Worth. Bruce is pictured high up on a ladder transferring the mural design of *Downtown Shops* onto the west exterior wall of the gallery. The Art Shop was open for 52 years. Maryanne is the executive director and artist coordinator of the annual Street Painting Festival.

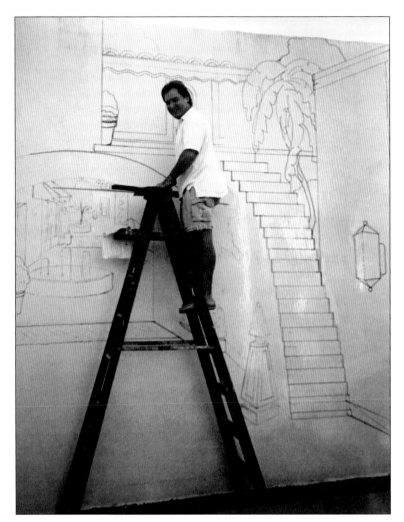

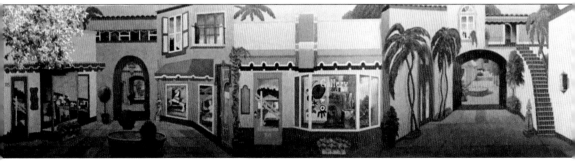

DOWNTOWN SHOPS COMPLETE. In 1994–1995, lead artists Bruce Webber and Robert Vorreyer (1924–2016), along with volunteer artists Richard Armstrong, Steve Hamsness, Clarence "Skip" Measelle, Beverly Mustaine, and others, created *Downtown Shops*, the fashionable street scene in the J Street Parking Lot. The mural measures 60 feet wide by 13 feet high. It was replaced in 2014 with a temporary, spray-painted mural by Miami street artist Oscar Montes, also known as Trek Six, during the *Going-A-Wall* live painting event. (Courtesy of Maryanne Webber.)

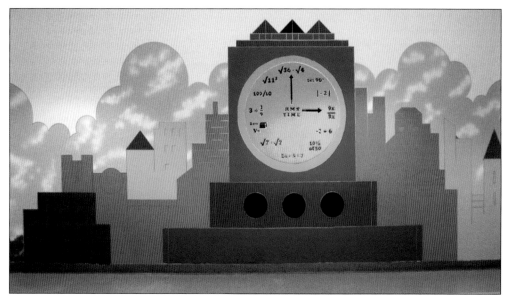

Math City Clock Detail. JoAnne Rogers, principal of Roosevelt Community Middle School, a Math, Science & Technology National Merit Magnet School of Distinction, engaged Sharon Koskoff as an artist in residence. Students created murals that embodied the principles of the school (see page 74). Artists Papa Ruby, Jose Gaddi, Rachel Roseman, and other volunteers also worked with youth during the project in the summer of 2012.

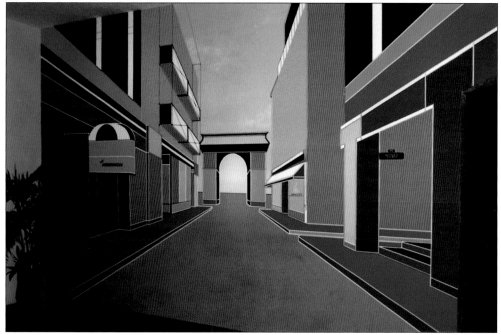

Washington Square Detail. The New York–themed mural painted at 3 G's Gourmet Deli, at Okeechobee and Palm Beach Lakes Boulevards, was commissioned by the Garnett family—father Marvin and sons Bruce and Andrew. Sharon Koskoff, Papa Ruby, and Ryan Kerner completed the stylized mural and celebrated with an opening reception on December 22, 1991. Although the Delray Beach 3 G's Deli thrives, the West Palm Beach location was demolished.

ART DECO STINGRAY CAFETERIA DETAIL. Construction Phase I of the Palm Springs Community Middle School murals included all of the cafeteria walls. Shown is a skyline silhouette with Art Deco borders highlighting the school's mascot, the stingray. The food line entrance sported a mural of abstract kitchen utensils. Sharon Koskoff, Papa Ruby, and Jeff Locke worked through the summer of 2007 under the guidance of Principal Sandra M. Jinks.

PUTT'N AROUND GOLF DETAIL. A fluorescent dayglow mural on canvas was painted as the backdrop for an actual miniature golf course placed inside the Cornell Museum of Art in November 2012. Viewers wore 3-D glasses to see the neon and black-light colors in perspective. Sharon Koskoff's temporary mural in the Children's Interactive Gallery was sponsored by Putt'n Around Miniature Golf of Delray Beach.

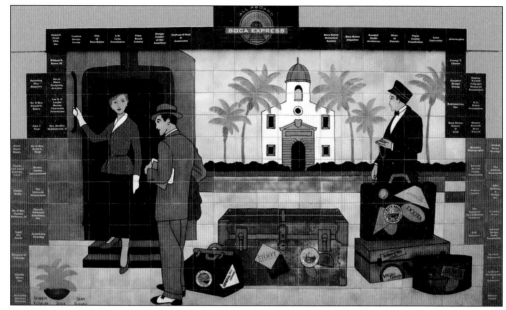

ALL ABOARD THE BOCA EXPRESS! In the summer of 2003, Sharon Koskoff and Sean Turrell collaborated to create a ceramic tile mural for the Boca Express Train Museum. The 1930s train exhibition, owned by the Boca Raton Historical Society & Museums, is located at the Florida East Coast Railway Station at the Count deHoernle Pavilion, 747 South Dixie Highway. Two 1947 Seaboard Air Line streamlined railcars listed in the National Register of Historic Places are on view.

BOCA EXPRESS OPENING DEDICATION. In the left photograph, Boca Raton mayor Steven L. Abrams (left) gives the introductory remarks on December 2, 2003, for the opening celebration and naming ceremony of the *All Aboard the Boca Express* mural. Sharon Koskoff (center) and Sean Turrell (right) accept the honors. In the right photograph, the Delray Beach studio of Sean Turrell displays 300 tiles of the Boca Express mural in progress with underglaze, waiting to be kiln fired.

PALM BEACH PUBLIX DETAIL. Lee Olsen created and donated four mosaic tile murals of Spanish conquistadors on the south side of the supermarket on Sunset Avenue in Palm Beach in the 1970s, when the grocery store was built. The structure was remodeled and reopened on December 15, 2011, with reproductions of the historic images fabricated and hung on the food chain's interior walls.

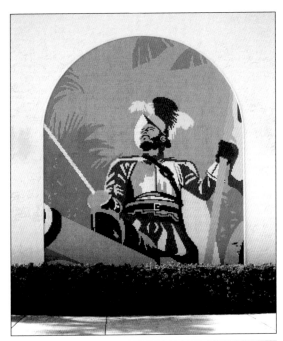

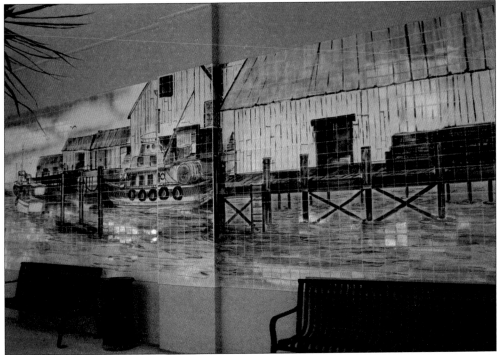

DOCKSIDE PUBLIX DETAIL. The Publix supermarket displays an original hand-glazed ceramic tile scene in the Hidden Valley shopping center on Federal Highway in Boca Raton. Winter Haven artist Pati Mills painted 200 murals throughout Florida on four-inch-square tiles in her Lake Hamilton studio during a 25-year span that began in the 1970s. Pati Mills's favorite themes were waterfront harbors, fruit, wine, bread, and the famous cornucopia. Inevitably, the significant murals are endangered as redevelopment occurs.

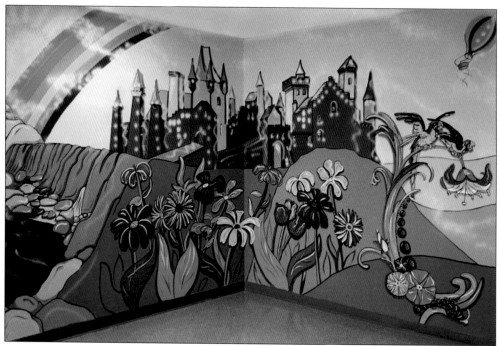

THE FREEDOM JOURNEY DETAIL. Hospice board member Henry Kaye recommended that Sharon Koskoff paint the Children's Bereavement Room at the Charles W. Gerstenberg Hospice at 5300 East Avenue in West Palm Beach. Koskoff and Papa Ruby worked closely with pediatric grief specialist Patrice Austin to create a fantasy mural where youth could receive loss support and comfort. The 63-foot mural was the only art in the ethereal institution of dignity, whose opening dedication was on July 31, 1992.

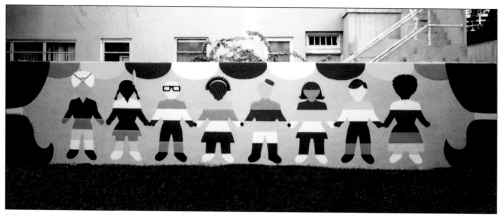

MULTICULTURAL CHILDREN'S MUSEUM. In the early 1990s, the City of West Palm Beach bought the lease for the Old Woman's Club on Flagler Drive, which dated back to 1916. Mayor Nancy Graham planned to turn the building into a children's museum, and Sharon Koskoff created the mural to announce the project. The museum was never realized, and the building was demolished in 1996 to make room for an open park space and festival stage.

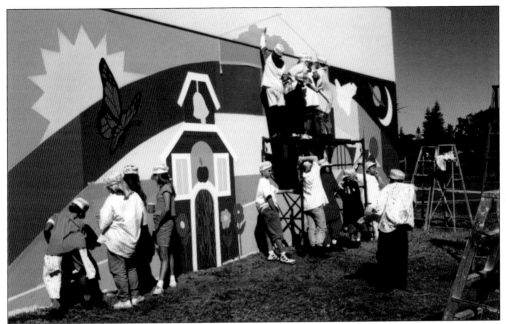

CHANGES IN PROGRESS. The Project LEAP mural *Changes*, painted on the 18-foot-tall, 48-foot-wide wall of Palm Springs Elementary School, faced Tenth Avenue North at Davis Road. Teachers Donna Tupper and Susannah Brown's fifth graders worked alongside Sharon Koskoff and Papa Ruby as they learned about transformations of life, nature, and history while supporting each other on ladders and scaffolding in December 1996.

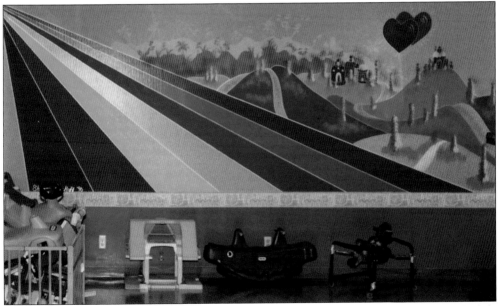

PEDIATRIC AIDS CLINIC. Ryan Kerner and Maggie Jourgensen assisted Sharon Koskoff while volunteering at the Palm Beach County Human Resource Services (HRS) Pediatric AIDS Babies Clinic at 301 Broadway in Riviera Beach on October 6, 1996. During that time, West Palm Beach had one of the highest rates of HIV in the country. A comprehensive AIDS program was established as the AIDS epidemic disproportionately affected poor and minority people.

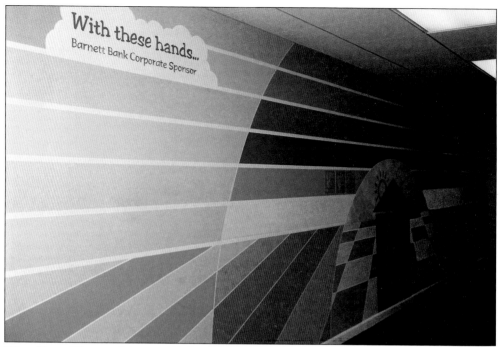

WITH THESE HANDS... Mary and Robert M. Montgomery Jr. raised over a million dollars for the at-risk children of abuse at Home Safe. Barnett Bank sponsored three murals (see page 27) painted on Sixth Avenue South in Lake Worth during the fall of 1996. Executive director Dr. Suzanne Turner supervised Sharon Koskoff and Papa Ruby in painting the mural, which lasted 20 years. Embossed handprints on Lucite squares were then mounted on the stripes of the sponsorship wall.

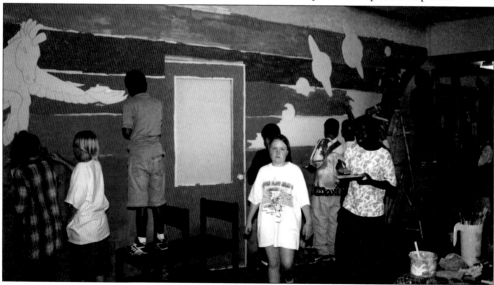

PEGASUS IN PROGRESS. Wanda Kirby's sixth-grade class at Jefferson Davis Middle School was the pilot for Project LEAP in October 1995. Sharon Koskoff collaborated with students while learning about mythology, constellations, and the solar system. Team-building skills were emphasized while painting library walls. The 1960s school was renamed Palm Springs Middle School, shedding its Confederate moniker, under the leadership of Principal Sandra M. Jinks in 2005.

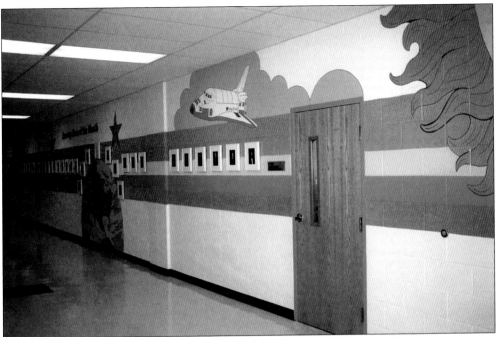

SOARING STARS OF THE MONTH DETAIL. Principal Bonnie Fox's philosophy for creating empowered students at Eagles Landing Middle School was to have Sharon Koskoff paint murals throughout with framed student portraits. When schoolchildren reached high or improved grades, they would be rewarded with their photograph on the wall for the month. Other incentive murals included the Academic Wall of Fame and the Athletic Wall of Fame. The murals, painted in 1998, adorned the school for almost 20 years.

ART DECO TEDDY DETAIL. Deloris Bradley and Judy Carter of HRS District IX hired Sharon Koskoff to paint the main lobby of the Economic Services Building in Riviera Beach with Papa Ruby. The mural design was completed on April 17, 1995. The 64-foot Art Deco graphic wrapped three walls where a peeping teddy bear with balloons entertained visiting children.

BARBIE'S BUTTERFLY GARDEN. Two freestanding walls at a right angle, with three-dimensional hanging butterflies from the ceiling, create a "room within a room" partition in the children's wing of the Cornell Museum in June 2009. Sharon Koskoff and James Borsos completed the installation in conjunction with the Barbie and Ken mural (see page 74). The fantasy environment inspired youth to make art.

FOREST THROUGH THE TREES DETAIL. Framed Adopt-A-Class 2004–2005 awards were displayed on an empty white wall at Discovery Key Elementary School's entrance until Sharon Koskoff, Papa Ruby, and Matthew Brown created a mural that transitions from forest to the Everglades to the solar system (see page 28). The complete 125-foot-long mural spans the entire lobby entrance and covers five walls and doorways.

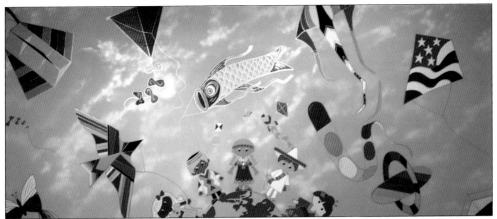

WORLD ON A STRING. The seventh mural Sharon Koskoff painted at the Children's Interactive Gallery at the Cornell Museum was a kite fantasy that celebrated multiculturalism in May 2013. The exhibit *Flying High: The Story of Kites* included artifacts from kite enthusiast Randy Lowe, the Morikami Museum, and a giant Chinese dragon kite hand built by Old School Square chief executive officer Joe Gillie.

PAINT UP PINE GROVE COLLAGE. The Pine Grove Elementary School courtyard artists are, from top to bottom and left to right, Sharon Kurlychek, Robin Faraday, Meg Goddard, Gladys Helena Beltran Posada, Deborah Matsunaye, Haydee Ullfig, Sharon Koskoff, Steve Brouse (see page 47), and Agata Ren. Delray Beach activists Steve and Lori Martel and developer Chuck Halberg organized the event and worked in partnership with Koskoff's *Art in the Alley* artists.

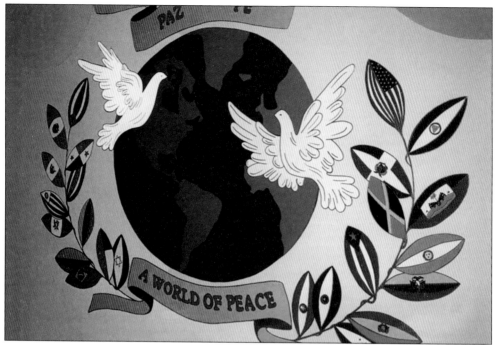

A WORLD OF PEACE. Reminiscent of the UNICEF greeting cards, Sharon Koskoff and Papa Ruby painted 24 flags representing North and South American countries at the cafeteria entrance at Belvedere Elementary School under Principal Sandra Brown and Assistant Principal Marsha Owens. Seven murals were completed in the summer of 2003, including the administration lobby and hallways, the cafeteria, on fine arts and music walls (see page 79), in the media center, and on the poetry wall (see page 42).

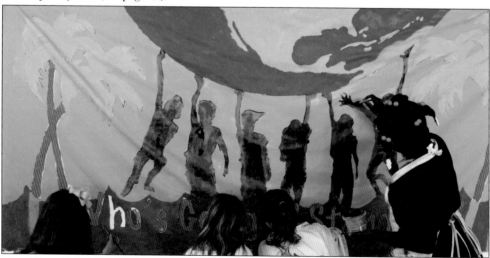

HIGHWATERLINE IN PROGRESS. Principal Cathy Reynolds praised Sharon Koskoff and Plumosa SOA students for creating the message mural *Who's Gonna Stand Up?*, endorsed by songwriter Neil Young. Eve Mosher's *HighWaterLine* created awareness in Delray Beach during the observance of Earth Day in 2015. Sharon Kurlychek and Ken Horkavy created a ceramic tile project and video. The international project brought awareness to climate impacts in New York City, Miami, Philadelphia, and Bristol in the United Kingdom.

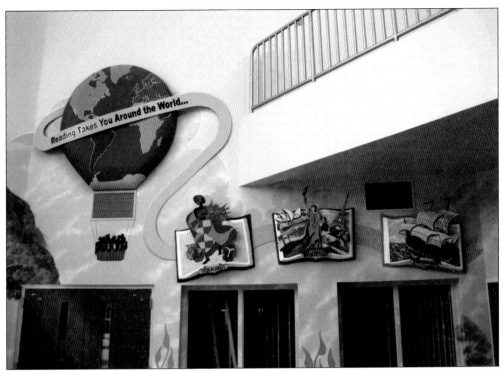

READING TAKES YOU AROUND THE WORLD. Westward Elementary School's mural enveloped the circular atrium lobby in the newly constructed international magnet school. Sharon Koskoff, Papa Ruby, and Joyce Goldman painted the mural background on-site. Eight volunteers assisted in Koskoff's studio to create a hot-air balloon and three-dimensional pop-up books *Folklore*, *Historical Non-Fiction* (below), and *Adventure*, made of wood, Styrofoam, plaster, and paint.

HISTORICAL NON-FICTION DETAIL. *Reading Takes You Around the World* includes the Statue of Liberty, surrounded by the Sydney Opera House, Eiffel Tower, Great Wall of China, and Great Sphinx of Giza. Mark Smith supervised the installation above the media center doorway on a Sunday afternoon, just in time for the first day of class on August 18, 2008. Boynton Beach sculptor Rick Beaulieu's globe of welded steel, centrally located on the ground floor (not shown), complements the project.

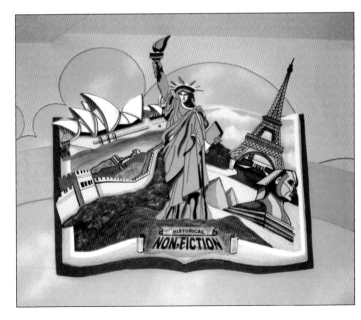

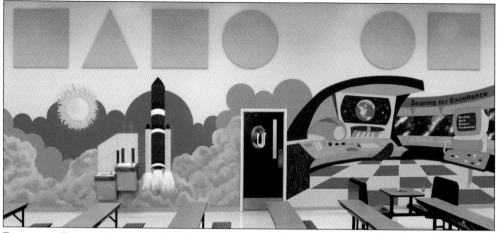

ROOSEVELT ROCKET LAUNCHING PAD DETAIL. Dr. Glenda Garrett and Marsha Owens of Roosevelt Elementary School had five areas of the cafeteria painted by Sharon Koskoff, Papa Ruby, and Matthew Brown. A space station, astronaut, solar system, and robot with space shuttle accompanied the launching pad mural, painted in the spring of 2005 during active schooldays.

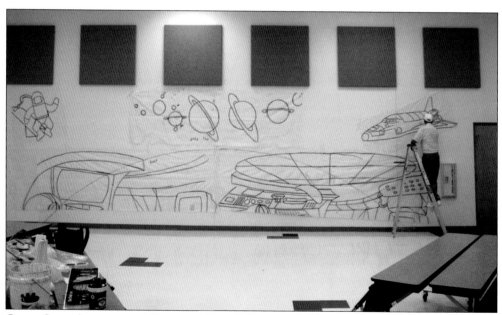

OUTER SPACE ADVENTURE IN PROGRESS. Papa Ruby is on a ladder transferring a template originally designed for Roosevelt Elementary School (above) at Crosspointe Elementary School in Boynton Beach. Sharon Koskoff and her father volunteered to paint the cafeteria of the Title I school when grant funding was insufficient. The acronym RICH (Respect, Integrity, Character, and Honor) was painted on a large sun centered on the wall.

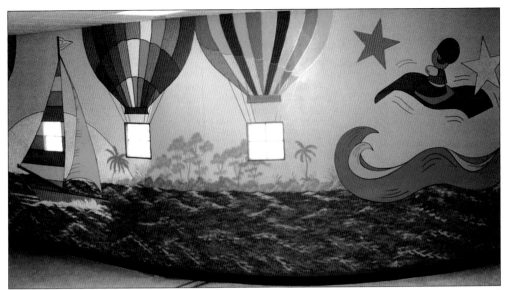

A JOURNEY OF DISCOVERY DETAIL. Architects Song and Associates built Odyssey Middle School in a modular design that allows for multiple locations of various programs. Sharon Koskoff, Papa Ruby, and many assistants, including Linda Fleetwood, painted one of the largest mural projects, measuring over 550 linear feet, in the purple-and-turquoise Boynton Beach school. Principal Bonnie Fox suspended painting for several weeks after the decimation of the Word Trade Center on September 11, 2001.

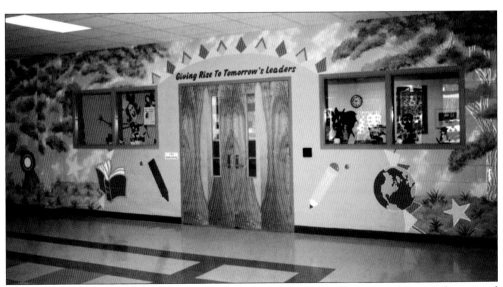

GIVING RISE TO TOMORROW'S LEADERS. In January 2002, Sharon Koskoff and Papa Ruby painted a 40-foot cosmologically themed mural on the walls surrounding the administration doorway in Sunrise Park Elementary School in west Boca Raton. Principal Alan Goldstein also had the *Friendship* mural painted inside the main office and a culturally diverse mural on the cafeteria's stage wall, requiring two levels of scaffolding. (Courtesy of Tyler Gray.)

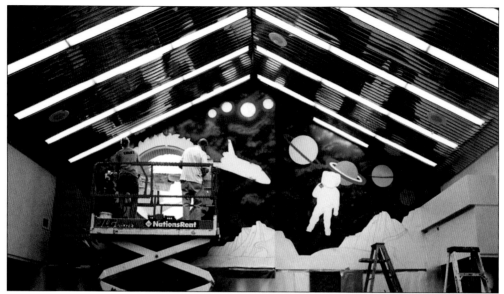

MY PLACE IN OUTER SPACE IN PROGRESS. Julia Ewart and Papa Ruby work 24 feet aboveground on a hydraulic scissor lift to paint the media center for the Northmore Elementary School Life Sciences, Mathematics, and Technology Magnet in July 2002. Sharon Koskoff used brilliant fluorescent colors and glitter to create the moonscape for Principal JoAnne Rogers's students on the sky-high wall with a Mylar reflective ceiling (see also page 81).

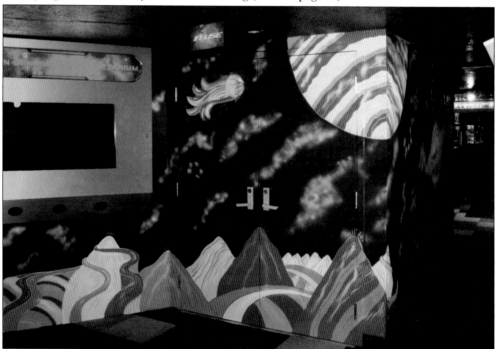

OUTER SPACE ADVENTURE DETAIL. The South Florida Science Center sought to emphasize the entry to the Marvin Dekelboum Planetarium laser light shows. The public was invited to watch as Sharon Koskoff and Papa Ruby painted a three-wall solar illusion in the Dreher Park facility in March 2010 (see page 28).

Five

ABSTRACT THINKING

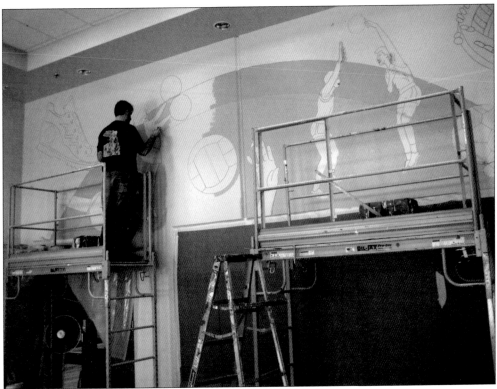

PALM SPRINGS COMMUNITY MIDDLE SCHOOL IN PROGRESS. Mural artist and photographer Geoffrey "Jeff" Locke is shown on scaffolding painting the background of a graphically designed gymnasium entrance during Phase II of construction on May 7, 2007. The "Home of the Stingrays" is at 1560 Kirk Road in West Palm Beach. Locke assisted Sharon Koskoff and Papa Ruby in painting 30 murals (see page 78) covering 53 walls at the newly built Art Deco–inspired school.

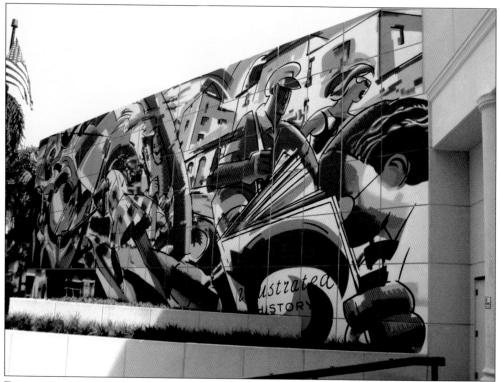

DELRAY PROGRESS (EAST WALL). In 2005, New Zealand native Andrew Reid and his team were commissioned by Palm Beach County Art in Public Places (AIPP) to create murals that celebrate community diversity, agriculture, industry, history, and present-day Delray Beach for the South County Courthouse at 200 West Atlantic Avenue. The two murals used 80 gallons of paint to cover 3,300 square feet of walls (see opposite).

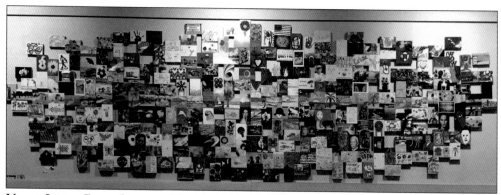

URBAN LIVING ROOM COLLAGE. The Mandel Public Library of West Palm Beach, at 411 Clematis Street, displays a collage of four-by-six-inch mixed-media entries from the community, including one from Mayor Lois Frankel. Grouped together, the artworks form a mural installation on the first-floor passageway connecting the street to city hall. F. Joan Goldberg of the City of West Palm Beach conceptualized the call for submissions in May 2009.

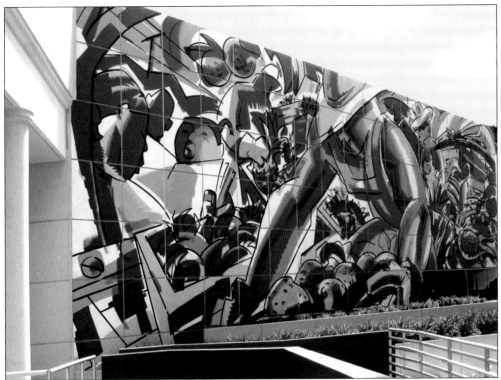

DELRAY PROGRESS (WEST WALL). Muralist Andrew Reid cocreated the mixed-media installation with ceramists Carlos Alves and J.C. Carroll, who built a 14-foot-tall ceramic-tiled pineapple sculpture, a dozen ceramic bench tops, and walls throughout the square. The public art activated the underutilized plaza to become an animated urban pocket park for patrons to enjoy. Reid is also known for murals at the West Palm Beach Police Station and Belle Glade Library.

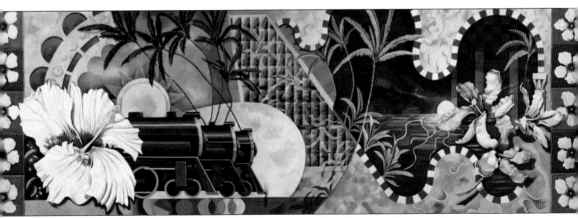

RESTORATION SEABOARD AIR LINE RAILROAD. West Palm Beach watercolorist, teacher, and museum educator Richard Frank (1947–2014) won a juried competition to create a 4-by-13-foot mural for the Tamarind Avenue train restoration project at Okeechobee Boulevard in 1991. He created an authentic vision for history buffs, preservationists, and train enthusiasts. The Seaboard Air Line Railroad building was built by Stephen Harvey and Louis Phillips Clarke in 1925.

UNTITLED. British-born artist Terry Haggerty enveloped the Shapiro Great Hall of the Norton Museum of Art in 2014, following Mickalene Thomas (2013, see below), Rob Wynne (2012), and Jose Alvarez (2011). The hard-edge acrylic painted environment was a site-specific installation that was generously supported by Vanessa and Anthony Beyer. (Courtesy of Norton Museum of Art, West Palm Beach, Florida, the artist, and Sikkema Jenkins & Co., New York.)

FAUX REAL. The third site-specific lobby installation for the Norton Museum of Art, by Mickalene Thomas, was created with vinyl, enamel paint, contact paper, and oil stick. Thomas deconstructed and reassembled photographic images using landscape elements and fractured perspectives to decorate the lobby in 2013. This installation was also generously supported by Vanessa and Anthony Beyer. (Courtesy of Norton Museum of Art, West Palm Beach, Florida.)

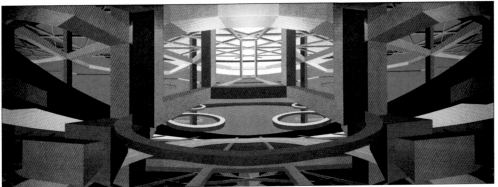

MANTEGNA'S EDGE. In 1983, New York artist Al Held (1928–2005) painted one continuous canvas measuring 14½ feet tall by 55 feet wide in acrylic. The hard-edge geometric was originally painted for the Southland Center in Dallas before being gifted to the Boca Raton Museum of Art by the New York Life Insurance Company. The canvas was revealed on January 24, 2001, opening day of the new Mizner Park location. (Courtesy of the Boca Raton Museum of Art, 1994.220, © 2017 Al Held Foundation, Inc./Licensed by Artists Rights Society [ARS], New York)

UNTITLED INSTALLATION. A new lobby mural by Venezuelan-born Jose Alvarez (D.O.P.A.) was installed in time for the Boca Raton Museum of Art's 65th anniversary in 2015. The psychedelic, pulsating mural collage is indicative of the artist's life story, filled with strange circumstance and wild exuberance. (Courtesy of the Boca Raton Museum of Art, 2017.74, photograph by Jacek Gancarz.)

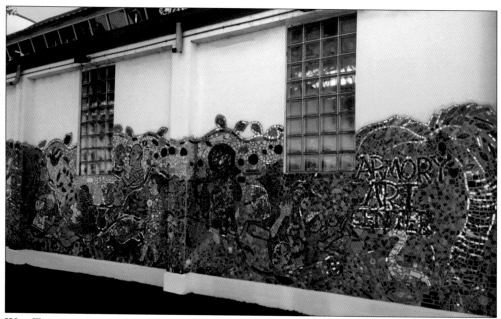

WALLTOGETHER MOSAICS. Arts education activists Alyx Kellington (1963–2012) and Lesley Davison served as project coordinators at the Armory Art Center's student tile mural project on the Muriel S. Kaplan building, visible from Howard Park and Parker Avenue in West Palm Beach. Hundreds of youth participated from 2006 through 2008. The community project received a grant from the Community Foundation's Mosaic Fund and money raised during the Palm Beach! America's International Fine Art & Antique Fair's 2006 Vernissage.

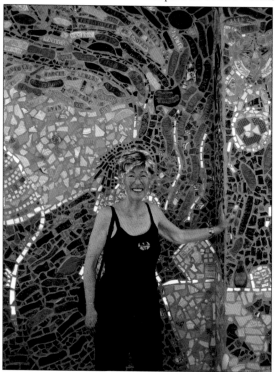

WALLTOGETHER WITH GAYE WOLFE. Armory Art Center founding board member Gaye Wolfe (1945–2012) stands before the hand-built mosaic mural in September 2008. Linda Fleetwood, Kathleen Holmes, and Gaye Wolfe created the first comprehensive artist registry for the Palm Beach County Council of the Arts in 1989. Gaye was a painter and community arts activist who helped revitalize Clematis Street in the early 1990s as the owner of Studio 412. She moved to Alaska in 2002 with Sam Smith, who held her memorial service at the art center on January 16, 2013, her 68th birthday.

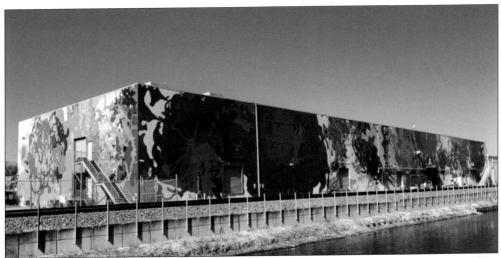

CLARE AVENUE WAREHOUSE. Cuban-born artist Jorge Pardo designed the largest canvas of his career in West Palm Beach at 1016 Clare Avenue in Howard Park, measuring 40,000 square feet. The structure was painted by muralists Daas, David Sanner, Gary Richie, and two others, all working for Sole Scenic of Orlando in January 2006. Pardo created the mural on a computer and supervised the arts team that succeeded in bringing attention to a blighted area.

POOL WALL MURAL. Public artist and sculptor Mark Fuller created this vertical installation, complete with ladder, diving board, and beach ball, above the shops at 704 Lake Avenue in early 2014. Emily Theodossakos, marketing and program manager of LULA Lake Worth Arts, worked closely with property owner Joseph Kirby to commission the whimsical mural. Fuller's art incorporates high technology and diverse fabrication methods, yielding state-of-the-art constructions. (Courtesy of Patricia Peters.)

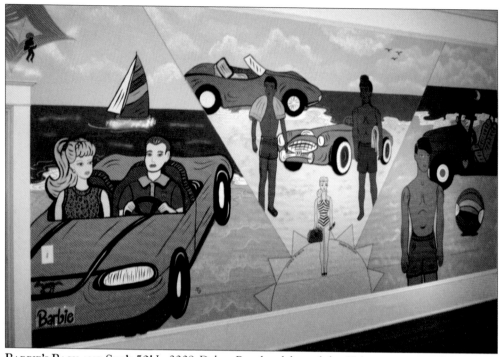

BARBIE'S BACK AND SHE'S 50! In 2009, Delray Beach celebrated the 50th anniversary of the Barbie doll. The Children's Gallery of the Cornell Art Museum of Old School Square commissioned Sharon Koskoff to paint a mural to enhance its exhibit and appeal to a large demographic audience. James Borsos volunteered his assistance painting the iconic images, which included four multicultural Malibu Ken dolls.

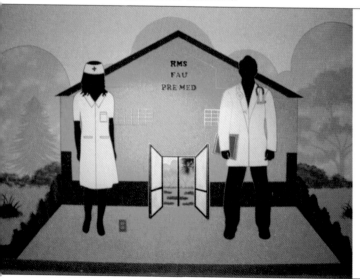

ROOSEVELT MIDDLE SCHOOL DETAILS. In the summer of 2012, Roosevelt Community Middle School principal JoAnne Rogers enlisted Sharon Koskoff as an artist in residence to work with students and community volunteers. Murals highlighting the magnet school's architecture and themes of science, premedical, and robotic technology were created throughout the grand lobby entrances (see page 52). Rachel Roseman and Papa Ruby assisted.

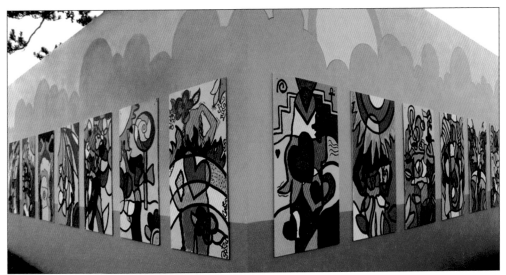

ART IN THE GARDEN. In the spring of 2012, Lake Worth Middle School teacher James "Coach Q" Quillian collaborated with his after-school Garden Club teens and Sharon Koskoff to create *Art in the Garden*. All 25 participants had their silhouettes projected onto a panel. The full-body portraits added a colorful dimension to the barren campus walls. Quillian and Koskoff also use the three-by-five-foot concrete panels for the fabrication of the *Art in the Alley* annual artist installations (see page 91). (Courtesy of Anita and Jack Dickerson.)

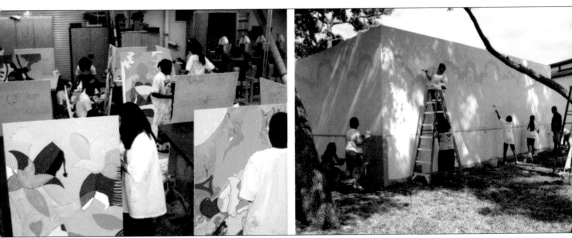

ART IN THE GARDEN IN PROGRESS. At left, Lake Worth Middle teens paint panels in warm and cool colors to create contrast. At right, students work with rollers and ladders to paint the landscape background for the mural panels. Volunteer Lindsay Moore, a *Sun-Sentinel* staff photographer, joined Koskoff to work with students on the mural project. Students received award certificates on April 28, 2012, in honor of Earth Day.

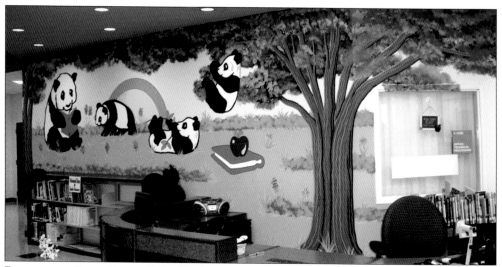

PANDAS THAT READ. Sharon Koskoff and Papa Ruby painted U.B. Kinsey/Palmview SOA Elementary School in West Palm Beach. Beginning on August 14, 2004, and struggling through Hurricanes Charley, Frances, Ivan, and Jeanne, the artists were finally able to complete the 11 murals on 26 walls in December. Principal Helen Byrd and Marsha Owens commissioned the pandas, the school mascot, for the media center and additional art in the administration lobby, cafeteria, hallways, and entryways.

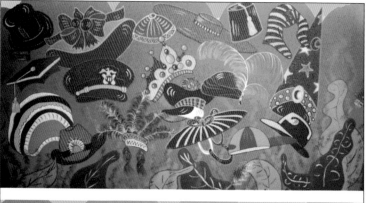

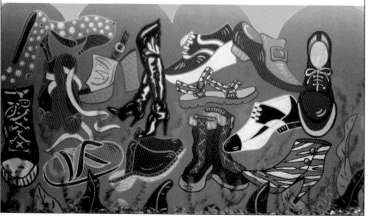

HATS AND SHOES. In 1997–1998, NARP Community Mural Project V was implemented on the campus of Atlantic High School in Delray Beach. Sharon Koskoff organized 96 volunteers and students, who painted twin murals depicting multicultural diversity through ethnic fashion. A third mural depicted a pair of cool sunglasses. Principal Carole Shetler selected highly visible walls with views from the cafeteria. The school campus became Plumosa SOA when Atlantic High School moved west of Interstate 95 in 2005.

MASTERS GO GREEN IN PROGRESS. The Art Deco Society of the Palm Beaches received a community grant from the Delray Beach CRA in April 2010 to create a "recycle, reduce, and reuse" mural at the old Plumosa SOA under Principal Priscilla Bowers-Maloney. In December 2011, Papa Ruby (right) is seated painting with students during the reinstallation at the new LEED Gold–certified green school, built on the former Atlantic High School campus under Principal Sally Rozanski.

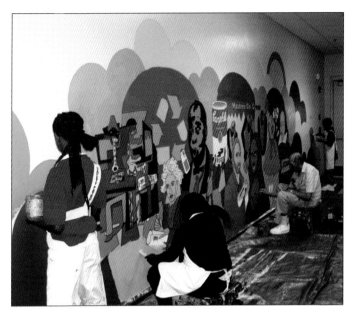

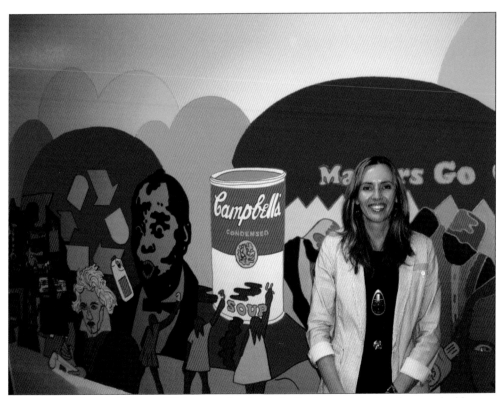

MASTERS GO GREEN. Plumosa SOA art teacher Jamie L. Davis stands before the mural of famous artists and masterpieces encompassing recycled images, remounted and site-specifically elongated. The canvas mural, painted on Earth Day, was rolled up and reused from the original elementary school located next door. Principal Rozanski and arts magnet coordinator Nancy Earley worked with Sharon Koskoff to create two more murals with students (see pages 26 and 94).

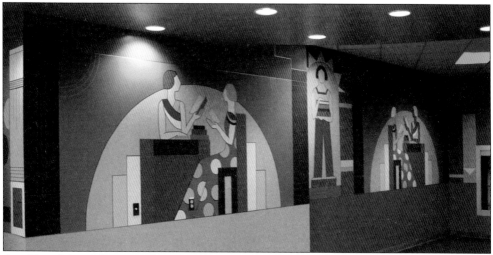

ART DECO MEDIA CENTER. The Palm Springs Middle School Media Center reflected the Jazz Age and was painted with geometric Modernist murals. The school's architects, Schenkel & Schultz, won first place from the Florida Educational Facilities Planners' Association at the School District of Palm Beach County's 2007 Architectural Showcase in West Palm Beach. The project coincided with the release of Sharon Koskoff's first book, *Art Deco of the Palm Beaches.*

GEOMETRICALLY DECO DETAIL. Indian Ridge School is a special day school, serving all of Palm Beach County from kindergarten through twelfth grade, whose students have been identified as emotionally or behaviorally disabled. Principal Sherri Kelty engaged Sharon Koskoff to paint the administration, media center, cafeteria, hallways, lobby entrance, and conference rooms in an Art Deco theme. Papa Ruby and Jeff Locke assisted in December 2007.

THE JAZZMAN AND THE BEE DETAIL.
Sharon Koskoff created her iconic Art
Deco *Jazzman*, this time holding a
trombone at the music room entrance
in the Fine Arts Hallway of Belvedere
Elementary School. The school mascot
bumblebee is buzzing to the melody.
Koskoff and Papa Ruby painted the
63-foot mural in the spring of 2007. The
Jazzman is the logo of the ADSPB, which
Koskoff founded in 1987. (Courtesy
of Loretta Muliero and Ray Nell.)

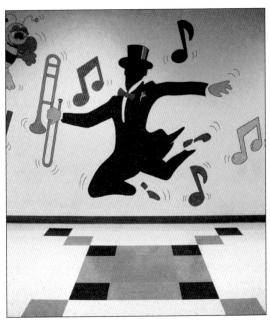

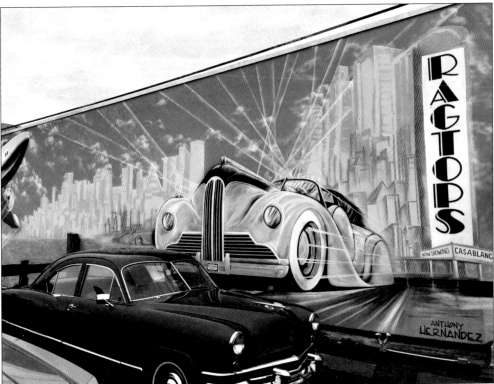

RAGTOPS MOTORCARS, PALM BEACH. Street Art Revolution's Cuban-born artist Anthony Hernandez
and Craig McInnis painted the Art Deco–styled mural at 420 Claremore Road facing Dixie Highway
at the antique car and automobile museum. Hernandez is a founding member of the Street Art
Revolution collective along with Caron Bowman, Eduardo Mendieta, and Dahlia Perryman, who
as art rebels against the establishment highlight local street artists in West Palm Beach.

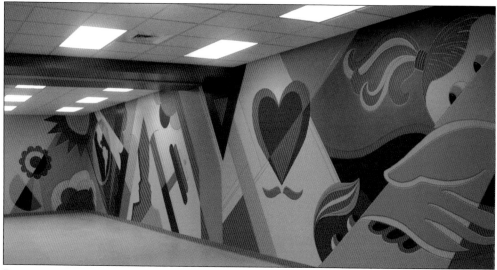

RESPONSIBILITY, RESPECT, CARING, AND HONESTY DETAIL. Sharon Koskoff, Papa Ruby, and Matthew Brown painted the Peter Blum Family YMCA of Boca Raton in September 2005, adding fitness, swimming, and child care to the community centers responsibility-themed artwork. The Y's new expansion opened with an abstractly painted multipurpose room. The mural embellished the walls through 2009, while Vicki Pugh was the executive director. The stucco-walled mural spanned 92 feet.

DUO AT THE ZOO. *Boo at the Zoo* (top) and *Winter in July* (bottom) are four-by-eight-foot wood panels painted in 2002 at the Palm Beach Zoo at Dreher Park by Sharon Koskoff, Papa Ruby, and Julia Ewart. Koskoff poses with the penguins before actual snow is delivered. Development director Sue Steffens commissioned the holiday-inspired murals for interactive children's events at the facility that inspires education and conservation.

THE GEOMETRIC GARDEN. At Northmore Elementary School, Sharon Koskoff created a mural that teaches math to students through a progression of geometric shapes disguised as flowers, from the continuous line of the circle to the eight-sided octagon. Koskoff and Papa Ruby also created a transportation collage mural in the student cafeteria and a sky-high mural in the media center (see page 66) in May 2002.

TENTH ANNIVERSARY CELEBRATION! Westgate/Belvedere Homes CRA's spring festival, led by redevelopment specialist Sharon Sheppard, enchants with a day of family, fun, and friendship. Sharon Koskoff designed an 18-foot-wide black-and-white canvas, and children were invited to fill in with markers during the event, which provided community outreach by partnering with public, nonprofit, and for-profit entities. Dozens of youth completed the mural for the annual event in 2016. (Courtesy of Jared, Talia, and Ariana Katz.)

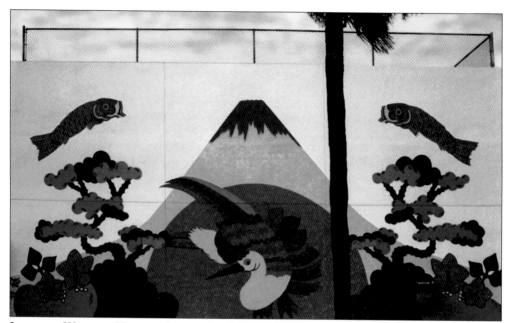

JAPANESE WALL OF HONOR. Art teacher Karin Kleinpeter, Joanne Newsome, and William Proctor's sixth graders of Carver Middle School learned about respect and integrity with Project LEAP's Sharon Koskoff under Principal Carol Blacharski and in-school coordinator Suzanne Schwartzman. Morikami Museum director Larry Rosensweig and Sister Cities of Delray Beach were consulted. Ryan Kerner, Elizabeth Byron, Carolyn Zimmerman, Karen Rose, Helen Kelsey, and Maggie Jorgensen also volunteered in April 1997 on the Miyasu Sister City wall facing West Atlantic Avenue. (Courtesy of Chris McKeown.)

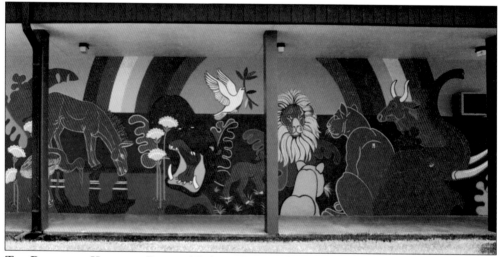

THE PEACEABLE KINGDOM. Principal JoAnne Rogers of Pine Grove Elementary School wanted to instill student nonviolence, so Sharon Koskoff painted a peaceful mural. The mural, facing Southwest Tenth Street in Delray Beach and illuminated by night, was the 1996–1997 NARP grant's Community Mural Project IV. The corner-wrapped mural was painted by 74 volunteers and led to 10 additional courtyard murals when the school became a fine arts magnet. The landmark was demolished 18 years later. (Courtesy of Elisa Muliero.)

BODY GRAPHIX, BELLE GLADE. In 2014, the Boys & Girls Clubs of Palm Beach County contracted Sharon Koskoff, partnering with the Solid Waste Authority and Palm Beach County AIPP, to create an 80-foot mural spanning the Bill Bailey Community Center Gymnasium on Dr. Martin Luther King Jr. Boulevard. Koskoff received a commendation from Rep. Alcee L. Hastings for the project, and Palm Beach County TV Channel 20 filmed the mural's progress for an episode of its *County Connection* series.

BODY GRAPHIX IN PROGRESS. At left, Dcjountalay "Pebbles" Coney poses for a full-body silhouette drawn by Sharon Koskoff onto a four-foot-by-eight-foot wood panel. The 24 teens added meaningful images to their portraits alongside supervisor Corey Federick, community volunteers, and local mentor artists Donald Neal, Lester Finney, and Jermaine Webb. At right, mixed gallons of paint, portioned and divided by warm and cool colors, are ready for the Boys & Girls Clubs members to paint collaboratively on-site. (Courtesy of Gladys Helena Beltran Posada.)

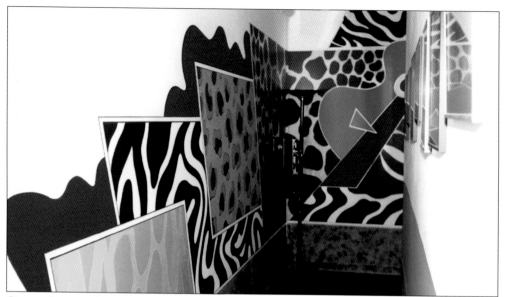

COFFEE GALLERY CAFÉ. For over a decade, Coffee Gallery owner Richard Kaminsky brought food, art, and nightlife to the renaissance of downtown Lake Worth at 517 Lake Avenue. The restaurant opened in December 1994 with local music guest performers, including Marie Nofsinger and Rod McDonald. Sharon Koskoff's graphically designed hallway was replicated for Coffee Gallery Café II at Cedar Pointe East in Stuart, Florida, in 1998.

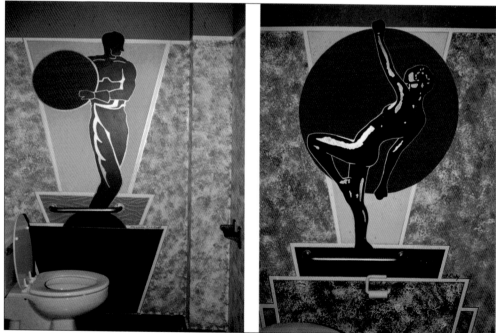

COFFEE GALLERY RESTROOMS. The men's and ladies' rooms at the Coffee Gallery Café were painted in faux finished marble patterns with majestic Art Deco figures by Sharon Koskoff and Papa Ruby in January 1995. The art scene blossomed downtown with the opening of the Palm Beach Institute of Contemporary Art (now the Cultural Council of Palm Beach County) across the street in July 1999. (Courtesy of Amy Clyman.)

Six

UNCONVENTIONAL
UNDERTAKINGS

SEEDLING IN PROGRESS. The Delray Beach Public Art Advisory Board (PAAB), led by chairperson Dan Bellante, parks and recreation director Suzanne Fisher, and the West Atlantic Redevelopment Coalition, worked with street artist Eduardo "Emo" Mendieta to paint an African American portrait on Northwest Third Avenue in the West Settlers Historic District of Delray Beach in September 2016. Street artists contracted and endorsed by public entities often use graffiti-styled spray painting techniques. Favorite themes are superrealistic images, bold geometrical abstracts, and large-scale portraits.

Dr. Martin Luther King Jr. Brazilian artist Eduardo Kobra painted his signature kaleidoscope portrait facing the rear sculpture garden of the Cultural Council of Palm Beach County at 601 Lake Avenue in Lake Worth for the CANVAS Outdoor Museum exhibition. In December 2017, the annual weeklong West Palm Beach event, which began in 2015, traveled to Lake Worth for the first time. Ten unexpected murals painted by artists from around the world will be on display for two years.

ABC Carpet & Home. In February 1997, four artists who call themselves the Snappy Turtle Posse painted a 445-foot-wide, 30-foot-high replica of the flagship store's 1886 brownstone in Manhattan onto the structure's exterior walls, visible from Interstate 95 in Delray Beach. The mural was restored in November 2003 after fading and discoloration. David Landy, ABC president, wanted to catch the attention of thousands of drivers who are familiar with the firm's New York store.

THE SPIRIT OF COMMUNICATION. In March 2014, Los Angeles–born street artist Tristan Eaton used 500 cans of spray paint to create a six-story mural on the Alexander Lofts building, formerly the Southern Bell Telephone Company, located at 326 Fern Street in West Palm Beach. Twenty-four months later, 40,000 pounds of bricks under the mural gave way, avalanching onto the structure below. The mural and closed street are pictured on March 25, 2016.

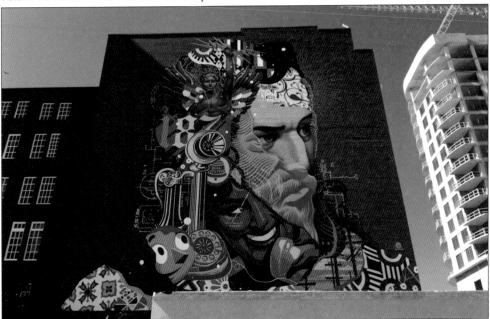

THE SPIRIT OF INVENTION. After repairs to the 90-year-old apartment building were complete, Tristan Eaton came back to replace his damaged urban masterpiece in August 2016 with another homage to Alexander Graham Bell. The international artist's work can also be seen in New York's Cooper Hewitt, Smithsonian Design Museum and the Museum of Modern Art. His colossal freehand murals are found around the globe from Paris to Shanghai.

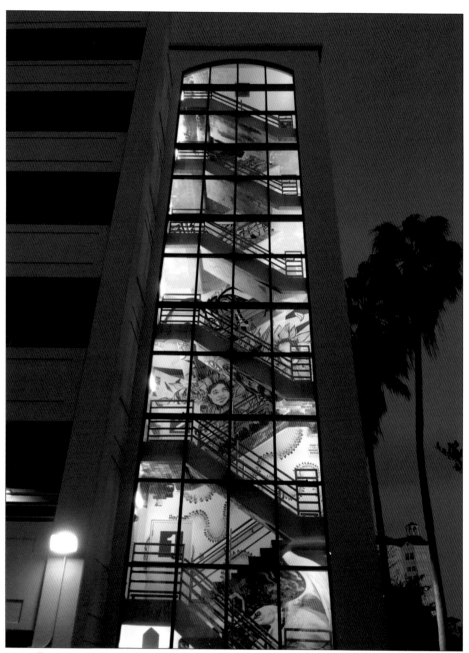

EVERNIA PARKING GARAGE. The Downtown Development Authority (DDA) of West Palm Beach sponsored seven-story "art galleries" in two stairwells of the parking garage with the approval of the City of West Palm Beach Parking Division and AIPP. The street art murals enhance the visitors' experience, and illumination provides interior safety and visibility to outsiders from floor to ceiling. Photographed at night, the south end of the Evernia Parking Garage on South Dixie Highway stands as a gateway to the city. Artists include (seventh floor) Eduardo "Emo" Mendieta, (sixth floor) Jay "Remote" Bellicchi, (fifth floor) Cassie "Kazilla" Williams, (fourth floor) Oscar "Trek Six" Montes, (third floor) Ruben Ubiera, (second floor) Douglas Hoekzema, and (first floor) Paul "PHD" Frederick Hughes.

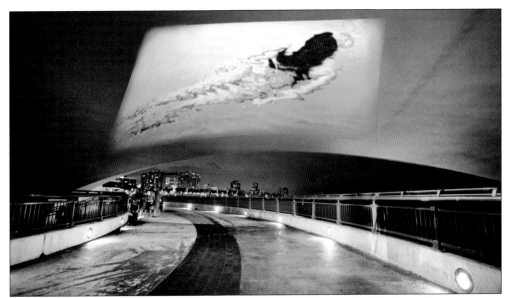

Submerge Video Installation. Under the Royal Park Bridgeway (middle bridge), photographer Cheryl Maeder created a public art video installation that was included in the inaugural CANVAS Outdoor Museum exhibition through the month of November 2015 on a roadway that connects West Palm Beach to Palm Beach. Jeri Muoio, mayor of West Palm Beach, Raphael Clemente, director of the West Palm Beach DDA, and Nicole Henry, CANVAS creator, all collaborated to implement the artist's illuminating vision.

Atlantic Avenue Bridge Underpass (AABU). In the southeast corner of Veterans Park in Delray Beach, local environmental artist Michiko Kurisu created a permanent installation that changes colors interactively with the movement of the Intracoastal Waterway. The first Delray Beach PAAB—chairperson Sharon Koskoff, vice chairperson Kevin "Kevro" Rouse, Carolyn Pendelton-Parker, Mary Smith, Patricia Truscello, Roger Hurlburt, and Vincent Dole—unanimously approved the unconventional aquatic-themed lightbox in 2006.

BAY GATES PROJECT DETAIL. In 1989, sculptor Rick Beaulieu petitioned the City of Boynton Beach to designate the Boynton Beach Neighborhood Arts District . Later in 2011, artist Rolando Chang Barrero organized and developed the ActivistArtistA Bay Gates Project, located at 410–422 West Industrial Avenue. Artists doors are, from left to right, mixed-media artist Nicole Galluccio, organizer Rolando Chang Barrero, and Salvador Dalí admirer Thomas Goetz. Gallery walks are held on the fourth Thursday of the month.

KEVRO'S ART BAR DETAIL. Artist Kevin "Kevro" Rouse and Deb Sullivan revitalized Bishop's Plumbing at 166 Southeast Second Avenue in Delray Beach and created a musical lounge with a visual arts experience. West Palm Beach artist Christos Michaelides painted the interactive exterior mural in December 2010. From left to right are James Quillian, Kevro, Max Boschetti, Karen Fragola, Al Sipp, Robyn Liable, Donnie Thorpe, and Lisa Quillian. The mural became blocked by new construction and the arts bar closed shortly after in June 2016. (Courtesy of Kevro.)

ART IN THE ALLEY. The sixth annual community volunteer event, conceived by Osceola neighborhood activists James and Lisa Quillian with artist organizer Sharon Koskoff, was held on February 6, 2016. Delray Beach residents Christi, Sara, and Steve Haley's panel, along with 48 others, painted 36 artworks cooperatively in the alley behind 211 Southeast Third Avenue.

HeArt in the Alley Installation. James Quillian measures the wall while installing the *Queen of Hearts*, painted by Tim Marking, creative director at Multi Image Group of Boca Raton, for the *Art in the Alley* Valentine's-themed event at Southeast Seventh Street, between Southeast Fourth and Fifth Avenues. The extraordinary event concluded with a block party on February 14 with reggae musician Chucka Riddim. Shortly after, Tim Marking suddenly passed at age 58, and his fellow artists held a memorial on September 27, 2016, celebrating his life and friendship.

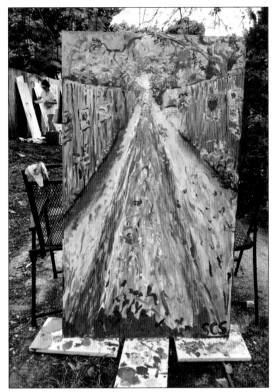

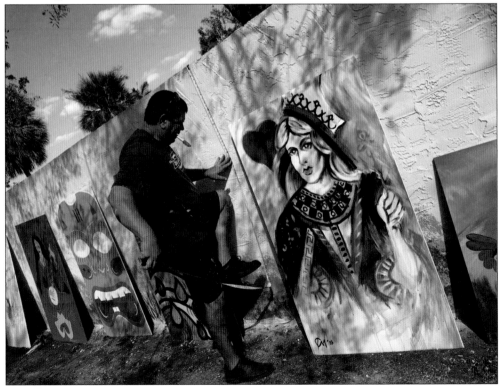

OPEN DOOR PROJECT IN PROGRESS. Artist Pam Melvin (left) paints Edvard Munch's *The Scream* on a screen door next to Arlene Canty's *Dolphin Door* backstage at The Pavilion of Old School Square, run by facility supervisor Marc Stevens and education director Jerilyn Brown. Sharon Koskoff envisioned and organized 75 artists who painted on 111 recycled doors. Dozens of volunteers donated, painted, and installed the project that celebrated the diversity of Delray Beach during the 2003–2004 season. (Courtesy of Steven Vincent Meier [1987–2015].)

OPEN DOOR RECEPTION. Glenn Weiss, director of Pineapple Grove Main Street, conceived of the *Cultural Loop* in downtown Delray Beach and retained Houston artist Rick Lowe, *Project Row Houses* creator, to connect art and the community. Sharon Koskoff's collaborative *Open Door Project*, across from city hall, created an active tourist destination. State senator Adam Hasner officiated at the reception. Standing in front of Scott Freeman's stained-glass door are, from left to right, Joe Gillie, Rick Lowe, Sharon Koskoff, an unidentified volunteer, and Sean Turrell.

FLOWER FESTIVAL 2000 DETAIL. Marjorie Ferrer, executive director of the Delray Beach Marketing Cooperative and the DDA, engaged Sharon Koskoff to design and lead community volunteers to "paint" with impatiens for the Y2K Millennium event. City workers constructed the framework that held 15,000 flowering plants for the sculptural living walls in Veterans Park during the winter season of 2000. Koskoff repeated the monumental floral installation in 2003 with Toussaint L'Ouverture High School students.

THE MISCHIEVOUS DOG. On August 31, 2017, *Clematis by Night* culminated with an art auction of fable-themed picnic tables by 19 artists paired with 25 nonprofit organizations. Adopt-A-Family of the Palm Beaches' Kelly Rigell (left) partnered with Sharon Koskoff (table shown) during the *Aesop's Tables* event organized by Mary Pinak, community events manager, and her team, along with Sybille Welter, West Palm Beach AIPP coordinator. Sharon Halupka-White teamed with Koskoff and painted *The Fox and the Stork*. The *Summer in Paradise* series continued with the *Global Fairytale Village* the following year.

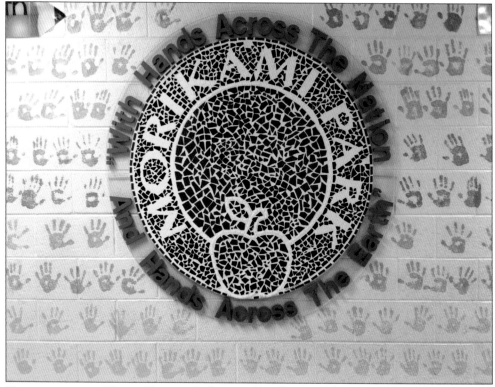

HANDS ACROSS THE NATION DETAIL. Orchestrated by Sharon Koskoff on May 7–9, 1999, staff and 850 students of Morikami Park Elementary School, an International Baccalaureate magnet in Delray Beach, had their handprints physically stamped onto the main hallway walls. Surrounding a mosaic tile wall hanging of the school's logo, each grade level's handprints are perpetually painted in a distinct color on the 43-foot wall. The mural commemorated the school's completion of its first year.

HANDS ACROSS PLUMOSA, HANDS ACROSS THE EARTH. In Delray Beach, Sharon Koskoff guides one of 540 Plumosa SOA students and 60 staff in May 2011 as human paintbrushes to create a "hand-scape" mural to celebrate the inaugural year of the newly constructed green school of the arts. Each enrolled student and staff member's handprints (1,200) were permanently placed in a panorama of roots, soil, flowers, trees, and earth, leaving their marks for posterity.

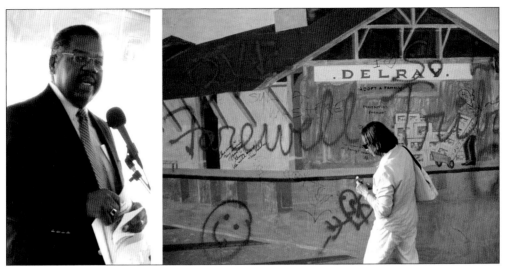

Love's Drugs Farewell Tribute. At left, Bill Nix, Cultural Council of Palm Beach County vice president of marketing and government affairs, addresses the original volunteers who painted the *Love's Drug Mural* in 1994. At right, Dottie Patterson, Delray Beach Historical Society archivist, spray paints farewell messages to the community at the media event held several weeks prior to demolition. The City of Delray Beach sanctioned the gathering in Pineapple Grove to acknowledge the landmark and its patrons (see page 16) on April 6, 2006.

Love's Drugs Demolition Detail. The demolition claw that destroyed the Community Mural Project I on June 2, 2006, waited until Sharon Koskoff arrived to capture the image. The full circle—from inception to implementation, process to actualization, and existence to complete absence—provided closure to the mural artist. The power of murals in public spaces provides a sense of place that may only survive through photographic means, continuing to provide a legacy of art, history, and cultural significance for future generations.

DISCOVER THOUSANDS OF LOCAL HISTORY BOOKS
FEATURING MILLIONS OF VINTAGE IMAGES

Arcadia Publishing, the leading local history publisher in the United States, is committed to making history accessible and meaningful through publishing books that celebrate and preserve the heritage of America's people and places.

Find more books like this at
www.arcadiapublishing.com

Search for your hometown history, your old stomping grounds, and even your favorite sports team.

Consistent with our mission to preserve history on a local level, this book was printed in South Carolina on American-made paper and manufactured entirely in the United States. Products carrying the accredited Forest Stewardship Council (FSC) label are printed on 100 percent FSC-certified paper.

MADE IN THE